The addictive sketcher

Adebanji Alade

the
addi-
sket

ctive
cher

SEARCH PRESS

Acknowledgements

All glory be to God for the life he has given me and for the talent and passion that burns within me every day to show forth His glory and shine my light for the world to see.

I never knew whether I would complete this book after allowing so many procrastinating fits to overwhelm me, but Edward Ralph, my editor, went through it all with me, listening to my excuses, made sense of all my chaotic ramblings and put it together into a book! Thanks also to my photographer, Gavin Sawyer, who snapped all these sketches and drawings in various lighting conditions while following me around London in the cold. I would also like to thank my creative director, Juan Hayward, for putting together all the graphics and design.

There could be no book without my Dad. He bathed me with books, and he believed so passionately in reading – he would rather go hungry than see me go without my books. I also want to thank my Mum for her precious love and encouragement in my life; she died a year after my dad in the most tragic circumstances when I was eighteen years old, but her life of sacrifice for us kids was second to none.

My education could have taken a big hit for the worse after my parents died but for a lovely trio: Mr Isaac Tapere, who sponsored my education, and Mr & Mrs Olutimehin, who adopted me after my loss and took care of me physically, spiritually and emotionally. Through their help I have become the man I am today.

This book would never be here without another quartet of four powerful ladies who shaped my life during the most rocky periods. They are angels – I know they have wings too: my two sisters, Mrs Funke Ogunyemi and Mrs Funmilayo Okusanya; my Spiritual Mothers Gladys Onwubiko, who set me up for success in the United Kingdom, and Mrs Stella Adigun, who didn't let me remain in my comfy day job.

And finally, I would like to thank my beautiful wife Ruth and two lovely kids Joshua and Kezia; who endured all the nights when I refused to come home and stayed overnight in my studio because this project had to be completed on time! I love you. This book would not have come to fruition without your constant checking, encouragement and reminders.

Dedication

This is dedicated to my first art teachers, Mr Mbaegu and Mr Idika Kalu. They saw this stuff in me and encouraged me at an early age to work hard and reach for the stars!

Publisher's note

The publishers would like to thank Jasmine Scott Neale, Alfie McNamara, Jiri Keller, and Liz Steel for their kind consent to appear in this book.

First published in 2020

Search Press Limited
Wellwood, North Farm Road,
Tunbridge Wells, Kent TN2 3DR

Text copyright © Adebanji Alade 2020

Photographs by Roddy Paine Photographic Studios

Photographs and design copyright ©
Search Press Ltd. 2020

ISBN: 978-1-78221-582-0

Suppliers
If you have difficulty in obtaining any of the materials and equipment mentioned in this book, then please visit the Search Press website for details of suppliers: searchpress.com

You are invited to visit the author online:
Website: adebanjialade.co.uk
Facebook: facebook.com/addictivesketcher
Instagram: @addictivesketcher

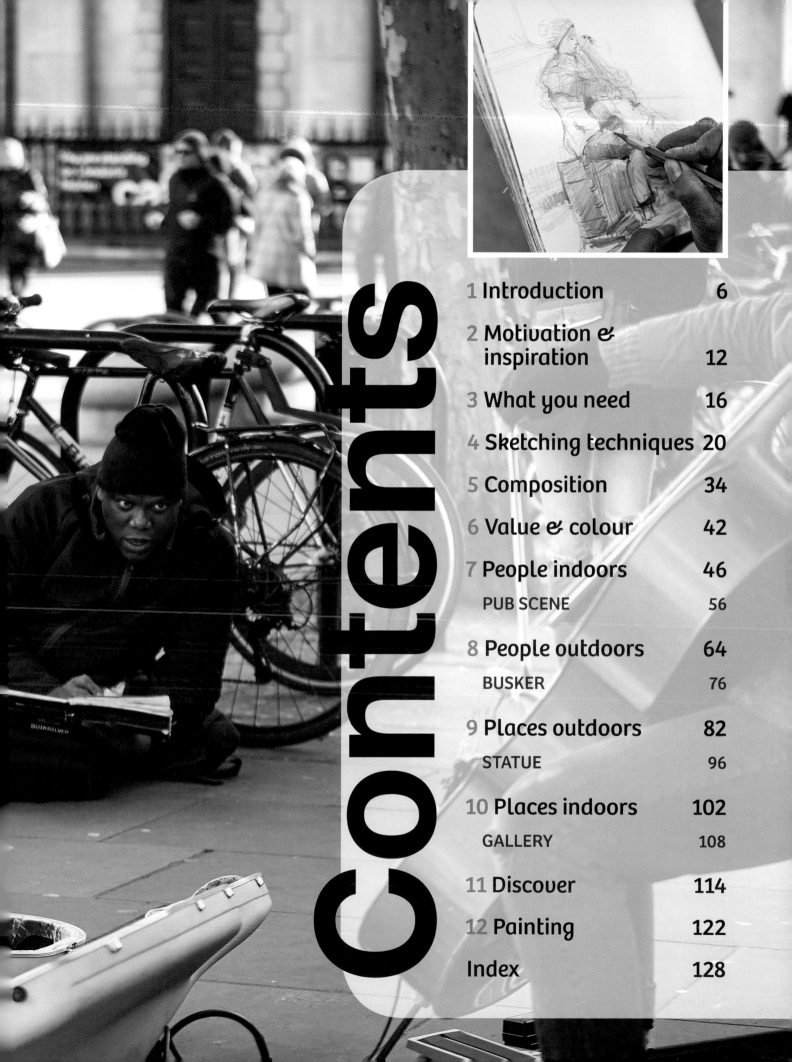

Contents

1 Introduction 6

2 Motivation & inspiration 12

3 What you need 16

4 Sketching techniques 20

5 Composition 34

6 Value & colour 42

7 People indoors 46

PUB SCENE 56

8 People outdoors 64

BUSKER 76

9 Places outdoors 82

STATUE 96

10 Places indoors 102

GALLERY 108

11 Discover 114

12 Painting 122

Index 128

INTRODUCTION

I love books; always have. My dad got me hooked. The one thing I never lacked while growing up in Nigeria was books. Our home had shelves full: I could see what my dad had read, and his marks and notes on them.

It was a book that changed my life at Yaba College of Technology in 1992. I remember the last day of the term in my first year at Art College. My good school friend Olusegun Mokayi – who is now a great sculptor and a lecturer at the same college – brought in a book, entitled *Sketch*, by Alywn Crawshaw. I was blown away. He kindly agreed to lend it to me. All through the holiday, before we resumed the next year, I basically mauled the book from cover to cover, practising all the exercises over and over – quite unaware that I was getting hooked on sketching.

When I resumed my studies, everyone in the class knew something had changed. I was always with a sketchbook now, carrying it everywhere around the school, and beyond. I headed out to busy local markets, sketching anything I came across; cows, people, trees, buildings...

I had suddenly found my passion. I was happier – in fact, I had fallen in love with sketching! It changed my outlook and philosophy on life forever. I believe you need to find something you are passionate about, and keep doing it with the same flame and desire that got you started.

If you can keep doing it, you will build a movement and following. This movement is the sketch addicts' movement. I hope this book will convert you into being a sketch addict – and I am sure you won't regret it: becoming one might well be one of the greatest decisions you will make on your artistic journey.

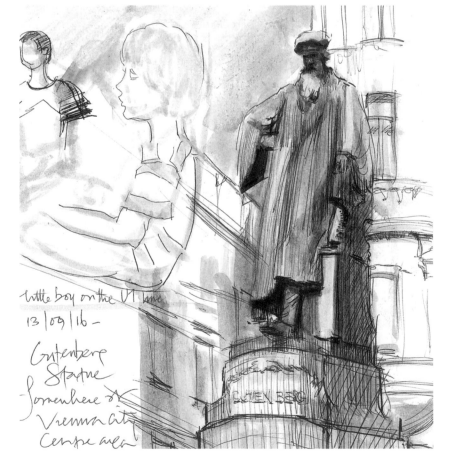

Why *The Addictive Sketcher?*

Yes – The Addictive Sketcher! That is what I call myself, and what I would love everyone who reads this book to become. After falling in love with sketching, I have never looked back. Sketching engulfed my life; I sketch every single day – and I itch and fidget when I am not sketching something or someone. When I can't sketch physically, I sketch within my mind – I know it sounds crazy, but that is exactly what I do. I simply imagine myself in the act of moving my pen to follow each contour and angle.

Sketching forms the basis of my art in general and keeps me going when my schedules get so packed that I have no time to paint. I believe this is what has made me a successful artist, and it has opened doors for me elsewhere: presenting art-related documentaries on the BBC's *The One Show*; teaching at Heatherley School of Fine Art and The Art Academy, London; motivational speaking at many secondary schools throughout the country; and who knows what next? I have always dreamed of acting in a Hollywood blockbuster as a sketcher. My wife thinks the last part about acting is a bit too adventurous, but I believe in dreaming big and taking risks.

When I am presenting I sketch, when I teach I sketch, when I speak I sketch. Sketching helps me gain full control in presenting my message in the most visual manner. If it weren't for my passion and addiction to sketching, I am sure many of these opportunities would not have opened up for me.

Finally, it's The Addictive Sketcher not only because of me but also because of you. I know you must have some kind of love for sketching, or you wouldn't have picked up this book in the first place. This book will totally change the way you see sketching, transform the way you sketch, and open doors and opportunities for you too. Even if you have no current plans to take your sketching to the next level, this book is for you. This book will help you to see what inspires me and I hope that it might just bring up something within you too, something that will keep you sketching and help you to see the world differently.

Once you catch the vision, you will never remain the same; you will spread the gospel of addictive sketching wherever you go, for the rest of your creative journey.

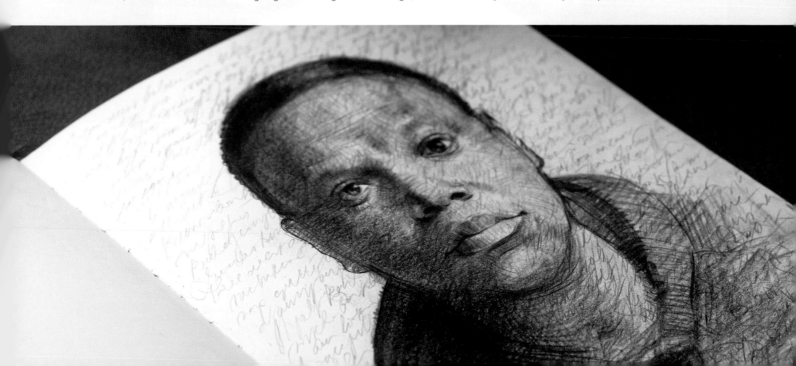

The habit of sketching

'We are what we repeatedly do. Excellence then is not an act, but a habit.' **Aristotle**

It is my utmost desire that, by reading this book, you will develop a powerful habit to sketch. Stephen Covey, the author of the bestselling book, *The 7 Habits of Highly Effective People*, said, 'Habits are powerful factors in our lives. Because they are consistent, often unconscious patterns, they constantly, daily, express our character and produce our effectiveness ... or ineffectiveness'. Most human beings long to make progress – whether in giant leaps forward or little baby steps – in whatever they are doing. They constantly want to get better than they were yesterday. You can wrap the whole aim of this book up in these few words: getting better by daily practice.

Daily practice is powerful! If, as you are reading this book, you decide to sketch just one thing from life every day, for at least fifteen minutes, you will be shocked at the progress you would make in just a month. Being faithful to my sketchbook every single day is how I was able to improve my sketches. The sketchbook is a living thing: it was never meant for the shelf or bags or pockets; it was meant to be carried in hand, everywhere, to quickly gain first-hand knowledge of what you see that interests you. It's almost like a camera, but it takes a bit more effort than just clicking. You must develop the desire to do it – I cannot give you give you that, but what I can give you, is how to do it and the motivation to keep improving your craft.

 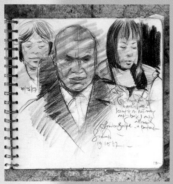 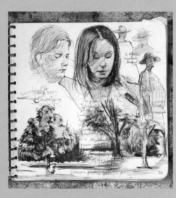

What do you love? The answer to that question is a good place to start. I started to develop a habit of sketching by choosing things to sketch that I found really interesting. This is what you must do. For some people, it may be flowers; for others, trees or animals; but for me it was, and still is, faces. I love the beauty, texture, youth, old age, different people from different places, the effect of light and shade on a face. My heart skips a beat whenever I am in a place where there are people to sketch. What makes your heart skip? Discover this and determine to improve your skills by doing it daily. Passion is the secret of sketching effectively; this is where the magic happens.

The first thing I want you to do is to get yourself a simple sketchbook. It does not need to be expensive or classy. With your new sketchbook in hand, set a target date to fill it, and try your best to keep to it. Let me warn you: there are going to be times when you do not feel like sketching, maybe because you are not seeing immediate progress. Well, that is not the point. The main point is to develop a habit. This book will give you the tips, knowledge and motivation to keep going when you feel like stopping. Just keep on sketching from life and make sure it is something you find interesting and keep finding new ways to approach it. Explore different media and keep at it. I can guarantee you that if you don't stop, by the time you reach the date you set yourself, you will be amazed at your progress. Remember: all improvement in art takes place because of the mileage. Keep sketching, and do not stop!

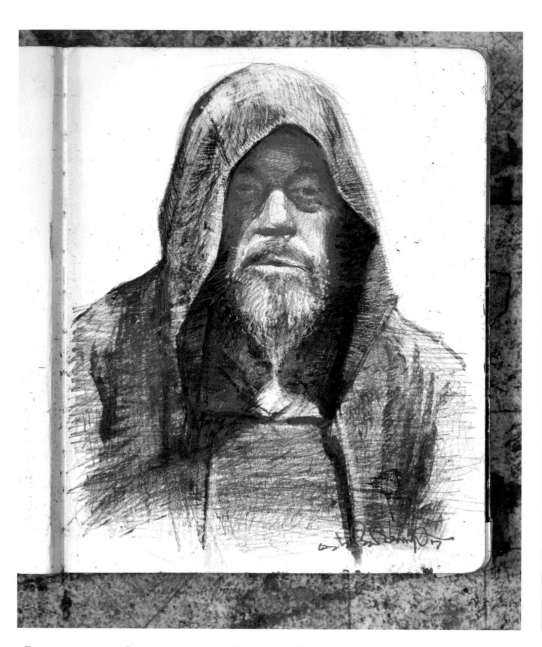

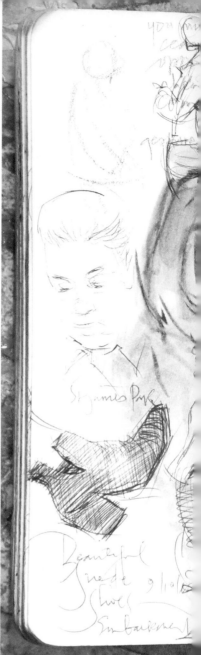

Appreciate and embrace your work

Being able to appreciate and embrace your own work at the very early stages of your development is one of the greatest gifts you can give yourself on your artistic journey. Even when your work does not make you pleased, and you do not feel great about what you are doing, look for the positives. Always find a way to put an optimistic spin on it – look for a detail that worked. The truth is that nothing is a complete disaster. In other words, do not be too hard on yourself.

Focus on the positives. One of the greatest qualities you are going to need is confidence. You need confidence in everything you do. You must approach your work with confidence, and confidence comes from practice. The more you practise, the better you get and this means you will start to feel better about yourself and what you are doing.

Many of the students I meet while teaching at Art schools and colleges pass very negative comments about their own work. Does it help? Certainly not! I have never seen anyone who has a negative disposition and made much of this creative business. Those that have risen to the top are the positive, enthusiastic and confident ones. They have a great outlook on life and it affects the way they see their work and embrace it.

I am not saying that you should brag about what you have done, nor am I saying that you should avoid all correction or criticism. I just know from twenty-five years of experience that you will emerge better and brighter at what you do if you celebrate the good. See what worked and how you progressed, even if it is just the sheer effort that you put in.

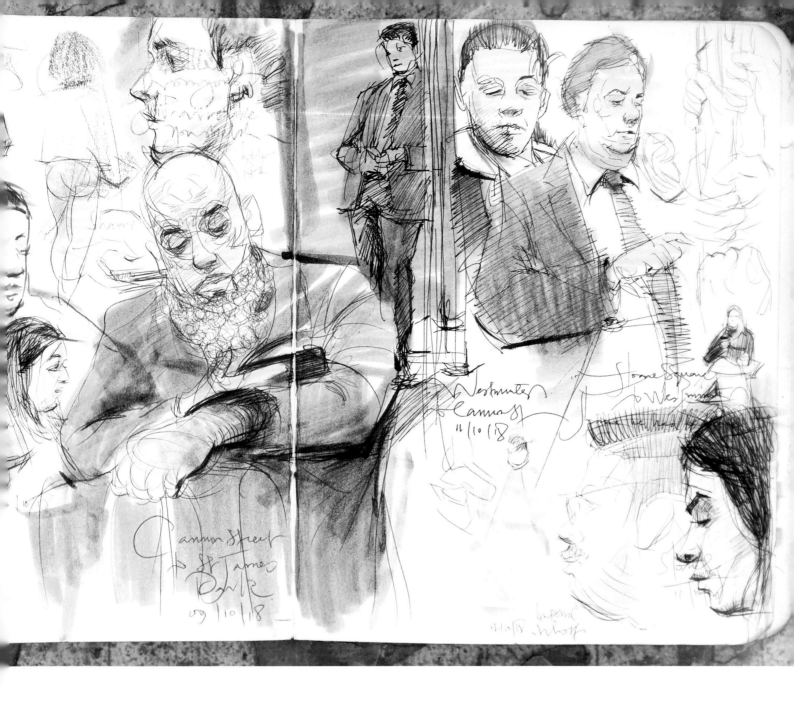

No matter where you find yourself, always know that there are thousands of people who would look up to you and your standard of drawing. Equally, there are thousands who are far better than you. Always keep this mind when you are working and it will help you to develop a healthy, wholesome view of your work.

When I just started developing the confidence to sketch outdoors while at College in Nigeria, I was sketching a few cows, and someone looked over my shoulder and said, 'That doesn't look like a cow.' That would have discouraged the fainthearted, never to venture into the outdoors again; but I had a different

Develop a healthy, wholesome view of your work.

disposition in those early days, which kept me going. I replied, with a bit of pride, 'It is only a sketch. It is not meant to look exactly like the cow – just a sketch, just a sketch.'

The onlooker laughed and so did I, but I learnt a serious lesson that day: never to take my work or myself too seriously. Having a sense of humour really helps in what I am trying to get across here – and remember, it's art – not brain surgery.

MOTIVATION & INSPIRATION

I wanted to get better at sketching because I paint portraits and urban landscapes. Without good sketching skills I knew I would not be able to make much progress in these areas, so I started my quest to learn how to do it properly.

The power of seeing

I am in total awe of the ability to see, and cherish the pair of eyes that I have. What if someone borrowed your eyes for a day and you were not able to see for twenty-four hours? Just imagine all the things you would have to miss – and the way you would feel when your eyes were returned. You would be more appreciative and grateful for them, and your experience with your eyes would be totally different. You would learn to use your eyes afresh and appreciate all what you can see around you in such a new way! Cherishing every opportunity to use my eyes informs how I approach my sketching.

As humans, we have the power to depict what we see in a 'drawing language' that no other animal can do. This makes us special, and I believe we can all do this with a reasonable amount of guidance and training. My first belief as an artist is that I have the ability and the power to see whatever is before my eyes and sketch it accurately without any interference from my brain. Once again I believe we can all do it. What normally sets us back is that we have too much information about what we know about things. When it comes to the time to draw what is in front of us, we bring too much of that knowledge into the drawing experience. If we rely just on what is in front of us – without all that information in our heads – we will be able to see more clearly and better able to put it down on paper.

Another way I relate to the power of seeing is in the way children see possibilities in the most mundane things. You put a child in the garden for a few minutes and they begin to explore. They look and keep looking. A single leaf becomes some sort of wonder. They pick up a stone and start grinding the leaf with the stone. They gather some twigs and all of a sudden they are cooking up something special. My questions then are these: Can you begin to see with the curiosity of a child? Can you face the world with excitement and purity of thought? Are you willing to cherish every moment and every experience as special to the point where you are fascinated with almost everything you see? If you are and if you can, then your pursuit of learning to see differently – plus your desire to do it accurately – will make you a powerful sketcher. You will tap into the real power of seeing. It is a blessing and it is a gift – so don't take it for granted!

12

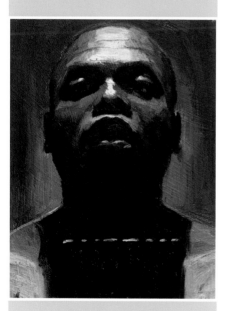

See, then sketch
In learning to sketch, I looked. I read art books and art magazines; I watched art DVDs, I went to art school, took art workshops and watched other artists paint and sketch. Over the years I gained an immense amount of practical knowledge on how to turn what I saw into what I draw; and this is what helped me to become a master sketcher.

Attitude in public

When sketching in any public space there are a few things that really help to make your adventure a pleasant one.

- Always be grateful to those who take the time to come over to where you are sketching and pass a comment about your work. Whether complimentary or derogatory, be thankful that they felt moved enough to approach you in the first place.

- Always ask permission to sketch in places like museums, galleries or hospitals. People are generally okay but it is always good to be sure. Follow your gut feeling.

- If someone asks what you are doing, or why, give them your sketchbook and let them have a look while you explain. This gives them the power and they will be more likely to listen and be reassured.

- Keep a simple smile or a pleasant disposition as you sketch in public. People feel more relaxed around you this way. If possible, show you really are in awe of what you are sketching. That alone can keeps onlookers absorbed in wonder at what a great time you are having.

- There's no need to speak to everyone around you if you find it distracting, but make sure you do your best to respond to those who make an effort to greet you.

- If the person you are sketching frowns or asks you to stop, be polite and respect their wishes.

- While sketching on trains I generally do not ask permission from all the passengers – if I did that I would never get anything done! However, as I sketch, I smile to try to make onlookers feel relaxed.

- If you are starting off sketching people on public transport, sketch the people who are sleeping or who are firmly glued to their smartphones and tablets; they are the best and will help you build your confidence.

- If you are sketching a homeless person or a busker, let them know what you are doing from the start, and ask permission politely. A generous tip or donation will likely give you sure access to a happy and very co-operative model.

- Never be aggressive or rude to anyone in public. If you are tried and tested beyond your limit, call for help. It is better that way than to be seen as a mad artist – and it will help make it easier and safer for the rest of us.

- If you are sketching at night, wear a bright, visible jacket. Keep your phone on you and take a torch. Most smartphones have torches.

- Keep the environment clean. Do not leave scraps of paper, tissue or pencil shavings after you. Take a small bin bag with you for all your mess.

- On a train, where you sit really matters. To get lots of sketches done, avoid sitting in the direction in which the train is moving, because most people sit that way. I love to sit at an angle where I can see and sketch without being too obtrusive. You don't want to be in people's faces.

- If you are not comfortable with people looking over your shoulders while sketching in public, find a wall that you can lean against so that no one can sneak up on you from behind.

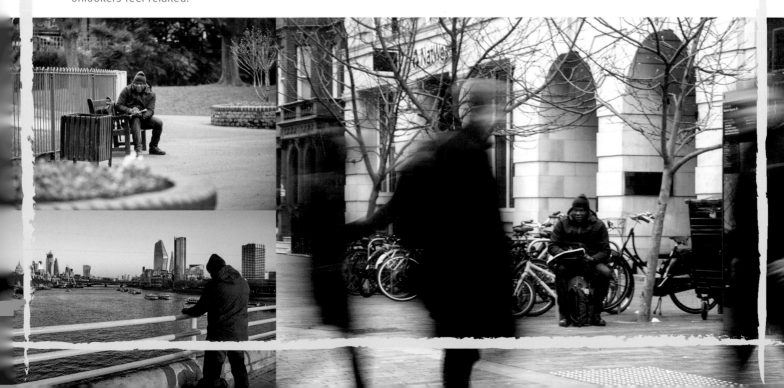

What will keep you going?

Everybody starts out with enthusiasm when they are excited about a new venture, but how many remain in that frame of mind in the middle of the project? To thrive creatively, you need to be tough. My advice is to remember what started you off in the first place. I constantly remind myself of the joy of being able to observe the world around me, and my intense curiosity to improve my drawing skills. Drawing never gets easier, so it is best to see it as an ongoing goal; one that will always demand practice. Because of this demand, I developed a motto: 'sketch, sketch, sketch, draw, draw and draw.' This single phrase has kept me going.

A strong 'why?' in any venture is a most powerful tool in getting results. My 'why' is that I want to share my passion for sketching with the world. I see myself as a prophet of sketching, looking for disciples who will feel the same thrills that I enjoy when drawing.

The third thing that keeps me going is just pure passion: the sincere love I have for good sketching and great drawing. I love when it is done well with a level of mastery. You can almost feel the page come to life when someone sketches something with deep intensity and feeling. I love to look at a plain page spread in my sketchbook and know that by the end of the day, it will be filled up with images that no-one but me will bring to life! Even when I am tired, I say to myself, 'Bring one more thing to life today; just one more.' It may just be a face, but that face would not exist if I didn't try. It is all about passion; but it requires work, effort and persistence to bring the passion to life.

One final thing: I am obsessed with the books and DVDs of the artists I admire. Make sure you stock up on works that inspire you. On days when you don't feel like sketching, you can go into your archive to read and absorb the writings and images of the artists you love.

Obstacles are what you see when you lose sight of your goals. I implore you to never stop going.

My inspiration

I'll pick up a book – any book – on John Singer Sargent, Anders Zorn, Joaquín Sorolla, Richard Schmid, Scott Burdick, Peter Brown, Quang Ho, Morgan Weistling, Susan Lyon, John Howard Sanden, Everett Raymond Kinstler, Scott Christensen, Ken Howard, Zhuo Shu Liang, Rose Frantzen, Trevor Chamberlain, Tim Okamura, Abiodun Olaku, Edosa Ogiugo, Leonardo da Vinci, Rembrandt, Velázquez, Diarmuid Kelly, and Andrew Festing. Just going through these artists' books, drawings, paintings or studies are enough to whet my appetite and fire me up! I never remain the same after a good bath in their realms.

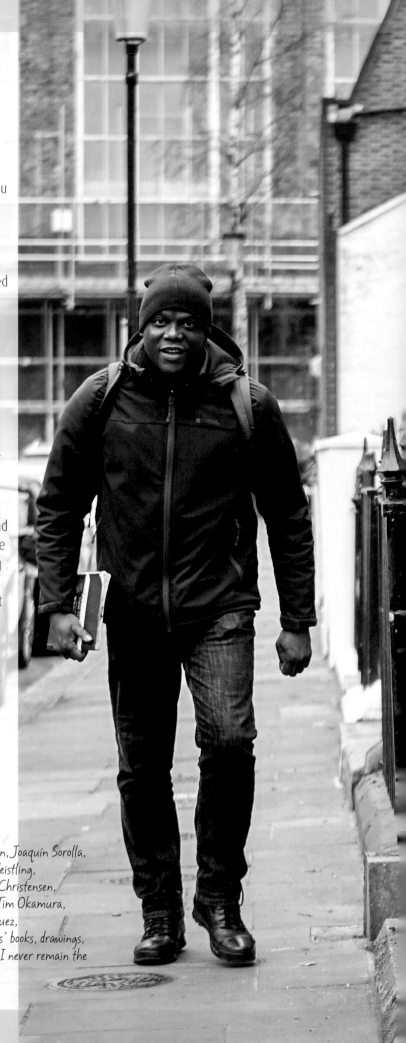

Pitfalls and challenges

There is a time in every project when the whole reason you started it will die. Be ready for this mini funeral: it will come. Once you recognize this, you can prepare for it – and then it will be easy to say, 'I knew this was coming, and I know you are not going to stay dead for long: there is a resurrection day too and I'm expecting that any time from now.'

Once you can treat this period this way, you will know it is not the end of the project, but just a period where you can prepare for its resurrection. Plan for that period, know how you are going to encourage yourself – and have it written down nearby!

HOW TO OVERCOME CHALLENGES AND MAINTAIN MOMENTUM

- **Maintain your course** Never compare the pace of your development with other artists', it is deadly. Use other artists to fuel your passion, but certainly not for comparison.

- **Don't take yourself too seriously** Sketching should always be mostly fun to do. Whenever a sketch does not work out as expected, remember to say, 'Hey, it's only a sketch'.

- **Keep everything** Never tear out a page from your sketchbook because it was not successful in your eyes. That would be too negative. If it didn't work, move to the next page. If they are torn out, how would you measure your progress and learn from your errors?

- **Avoid comparisons** Use of social media is great but bear in mind that no-one posts their failures. Remember, there are thousands of artists that are better than you and thousands more that you are better than. Don't let anything you see there make you depressed or overconfident.

- **Avoid financial pressure** When it comes to the artistic process and pursuit, never make your art the main source of your income when just starting out. Do other things to support your art, things that will take the pressure off you a bit, and that will allow you to practise on a consistent basis. No one ever thrived in the creative area with a pile of debt.

- **Start from the beginning** If you are waiting to be perfect, you will surely wait for a very long time. You will never be ready to show your work to the world, or advertize your sketch book to the masses. Start from where you are, and allow yourself space to thrive.

- **Make space** It is easy to get discouraged or distracted. Carve out a tiny haven at home or in your studio, where you are going to be able to work. Create an uncluttered place where you can just start sketching or drawing and make sure you keep to a particular time. For instance, if you have a day job, the early hours of the morning might be best and if you finish work a bit early, you might want to work on your passion afterwards. It does not have to be every day or for very long, but make sure it is a routine you can stick to.

- **Develop your habit** Never focus on trying to do a good sketch. Instead, focus on developing the habit of sketching. This will relieve you from the pressure of perfection and help you to keep going when you don't feel like it.

- **Avoid negativity** Be aware that the world is full of critics; they will gravitate towards you. Be careful not to let their derogatory comments affect your artistic stamina. Focus on what matters, and trash the rest.

- **Cultivate a healthy mind** Fill your mind with motivational quotes and material from personal development books that you know will help you to keep your mind healthy. You must have the right mindset when you venture into anything creative, so don't lose the battle in your mind.

- **Plan** Maintain a clear developmental plan to succeed and stick to that. That may mean you attend workshops, one-to-one sessions, art courses or art conventions where your favourite artists come together to demonstrate and explain their practice and skills.

- **Get support** When things are not going well, as sometimes happens, do not resort to anything destructive – too much drinking or smoking will just make things worse. Anything that you know is not going to serve your health is best to avoid. What most of us need while we are on this creative journey is a good network of supportive friends, plenty of rest and time to meditate and exercise, with some real good nutritious meals. Surround yourself with people who care, and avoid focussing too much on yourself: it's dangerous.

- **Find the right feedback** Competitions, awards, bursaries, residencies, open exhibitions, juried exhibitions and even sales are all good in that they help you by giving you feedback, revenue and some exposure, but never rely on their rejections or acceptances as a yardstick to measure your progress. What matters most is for you to make steady progress. This can easily be assessed by you, a trusted friend or teacher you know, who will really give you some positive feedback.

WHAT YOU NEED

Your choice of what to sketch with should be totally up to you. I want you to see your materials as an extension of your drawing hand. Do some exploration and experimentations, to try out different materials and find out what works for you. Whatever you decide to use should feel as natural as possible to you, and able to be used freely and comfortably. Once you find those that work for you, stick to those until they become tried and tested favourites. Mine are listed below. They never fail and are always the best for me.

My kit

My general rule for a sketching kit is to have something that can give you detailed or intricate parts of the drawing and something that can give you broad strokes or sweeps for larger masses or portions of the sketch. In addition, it all needs to fit into my backpack.

My most used sketching materials are a black or brown ballpoint pen and a cool grey (N75) or tan (942) Tombow dual wash pen.

My kit also typically includes:

· A selection of pencils – graphite in 6B, 4B and HB; as well as oil-based pencils; and mechanical or clutch pencils.
· A small watercolour paintbox and selection of brushes.
· A small plastic bottle of water and a spray bottle.
· Gouache paint
· A craft knife – this is used for sharpening pencils.
· Erasers – both electronic and normal erasers. I cut the latter into small pieces for highlights.
· Fineliner pens – I favour Derwent Line Makers because they create a consistent line and fluent marks.
· Sketchbooks – my favourite brands are Stillman & Birn, Daley Rowney and Moleskine because they all have good quality paper and are quite resilient. The Tombow dual wash pens I favour work particularly well on these paper surfaces.
· An Etchr Lab pouch – this is for storing and protecting the pencils and brushes on the move.

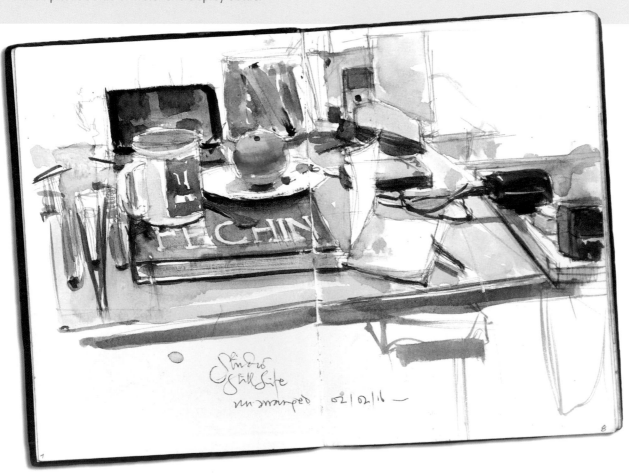

Pencils

Simple, straightforward and easy to access, pencils are my first sketching love and my preferred tools. I use mechanical pencils by Faber-Castell in 0.3mm, 0.5mm and 0.7mm sizes. These allow me to swap the leads between HB to 4B. I also use well-sharpened traditional Staedtler pencils in HB to 4B for details. For broad stokes I use chunky graphite sticks. The makes I love are Lyra graphite crayons and Koh-I-Noor Jumbo woodless graphite. Both are just graphite, with no wooden cases. Because of this, there is no interference: I can pick up a stick, sharpen it and manoeuvre it in different directions to produce the desired mark. I occasionally sharpen traditional cased pencils in a chiselled way to get the desired broad strokes (see details below).

A

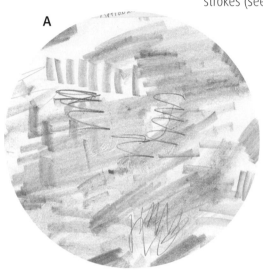

B

A This detail shows mostly broad strokes made with different pencils. I use this sort of stroke when starting off sketches, before changing to using thin lines for details.

B A mix of broad strokes and thin strokes, made with the same pencil. You can see how these can be combined in the sketch of the book here.

18

Fine pens

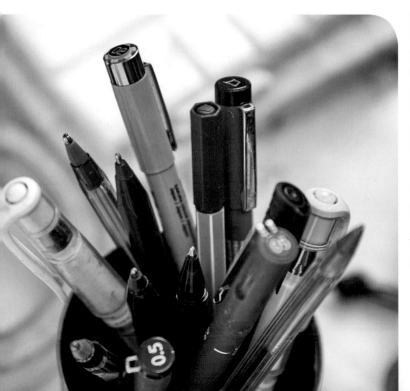

Of all the pens that exist on planet Earth, I am most grateful for Bic ballpoint pens because they allow me to be very precise and also get a variety of marks. They are what I use for most work that involves lines and cross-hatching. The other brands of ballpoint pens I use are Papermate InkJoy 101. I'll buy the pack of twelve just for the brown one.

Occasionally I also use Derwent Line Makers in 0.05, 0.1, 0.2, 0.3, 0.5 and 0.8 sizes. They are superfine and free-flowing permanent liners that bring out the beauty in drawing.

I also use Pentel 1.0mm Tip Hybrid Gel Grip pens in white. They come in handy when using coloured paper and also for highlights in a full-blown sketch.

Coloured pencils

I started to learn how to paint with coloured pencils. In fact, until I got into art college, I never really used paint – if there was a work to be done in colour I would use coloured pencils. I love Lyra Color Giants in assorted browns, greys, and blacks, because they are thick and bold. Just like the chunky graphite (see opposite), they help me to depict broad strokes easily by using the side of the tip.
I also like Faber-Castell's Polychromos and the Albrecht Dürer ranges of coloured pencils; along with Caran d'Ache's Supracolor watercolour pencils.
I also use oil-based pencils made by Faber-Castell in hard, medium, soft and extra soft. I love these oil pencils because they can produce the range of darks that one can get from charcoals, while being cleaner to use.

Paints

When it comes to adding colour to my sketches or working on a full sketch in wet media, I love watercolour and gouache. I tend to use Winsor & Newton's artists' quality paints for both, using them together to get a range of transparent and opaque passages in my work.

Generally I use synthetic brushes, mainly rounds, but I use any sort of brush that has good holding power – that is, it carries enough paint – and can be used to get both good pointed marks for details and large sweeps too. These include Daler Rowney Aquafine brushes; Pro Arte Series 40; and Winsor & Newton's Series 7 – the latter being pure sables of the highest quality.

Markers

I use brush markers for tones and covering large areas of value. My favourite range are the dual brush pens from Tombow. They have a nib at each end; one larger, one smaller. I really love the range of browns and greys they have. I buy their cool grey 5 (N65), cool grey 3 (N75), tan (942), sand (992), warm grey 1 (N89) and warm grey 2 (N79). I use them for sketching alongside the ballpoint pens.

The other sets of brush pens I use are ZIG Art & Graphic Twin dual wash pens. I sketch with these directly onto my sketchbook, using them not just for tones but also for direct sketching onto a board or canvas to start a painting. Again I love their range of browns and greys.

SKETCHING TECHNIQUES

'Learning to see is what drawing is all about' **Sherrie McGraw**

Making measurements

We must trust our eyes. They always know whether the object we are trying to sketch or draw is proportionally correct. My take on measuring and proportion is to measure only very succinctly. I look for the main landmarks. In a human figure, this might be how many heads fit in the whole figure; for buildings it could be how many floors. However, that is as far as I would go. Laborious measuring takes away the beauty and full immersion in the drawing process. If everything becomes mechanical and measured, then it is better to go to the technical class or the architect's studio.

My basic method to get accurate proportions is to hold a pencil at arm's length. I line up the end of the pencil with the top of what I am measuring and place my thumb where the first measurement would be. The distance between the end of the pencil and thumb lets me see how many repetitions of that particular distance I can fit on my paper. Once I know this, I can make faint lines on my sheet of paper, which serve as a guide – just a guide, no more and no less – for the rest of the drawing. I trust my eyes and enjoy the process of connecting one part of the drawing to another – and so bring the sketch to completion.

However, imagine if I was constantly stretching out my hand to sketch on the Tube or trains in London? People would think I have gone mad and I would never be able to get anything done. Just go for the landmarks and leave the rest for the eyes. If you train your eyes to figure out the rest, they won't be slaves to meticulous academic measuring techniques.

If you can adapt to such a simple way of seeing, you will enjoy the process of sketching with a freedom which relentless measuring can rob us of. Allowing your eye to judge approximate proportions is a great exercise. Because the brain is so powerful, it will take the right information from the eyes; and quickly pick up when something needs adjusting. 'Trust what you see and not what you think' is the best advice when it comes to measuring and proportion.

Just as you trained yourself to know how much water you need to add to squash without a measuring jug, or how much milk to add to tea without using a ruler or pair of dividers, you can learn, through practice, how each measurement relates to others in the correct proportions through calculated risks and leaps of faith. Trust your eyes and your ability to make it right: your eyes will respond to such training and this will let you make judgements and measurements without becoming too rigid in your approach.

Storage, transport and care of your tools

When you take care of your tools, they will take care of you too, helping you to produce good works. I mainly use an Etchr Field Case to store my pens and pencils securely. It has lots of compartments and helps to keep everything I ever use for a sketching exercise safely and in good condition.

When working outdoors, I keep all my tools in groups – all coloured pencils together, all pens together, and all brush markers together – tying each group with elastic bands to help me maintain some organization. I can then quickly and easily choose which group to work with.

At home, you must make sure all your pens and markers are kept in a cool place where they won't be exposed to too much heat or too much cold, as this will cause brush markers and pens with nibs to dry out. Never forget to properly cover all your pens and their tops; once they are exposed to the air, they dry out in no time.

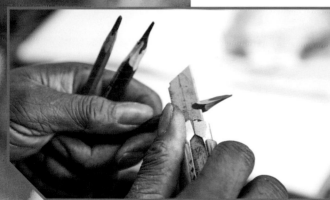

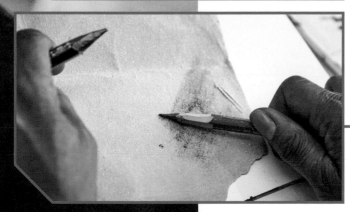

SHARPENING PENCILS

When sharpening pencils I am always careful to make sure that I use a very sharp blade. I follow the sides of the pencil in an upward direction and flick, making sure that the lead or pigment remains sharp and tapered (top image). After this I give it a rub over fine sandpaper (bottom image) in a circular motion to remove any rough edges. I apply very little pressure when using the pencils in this way, as they become quite fragile and break under too much pressure or force.

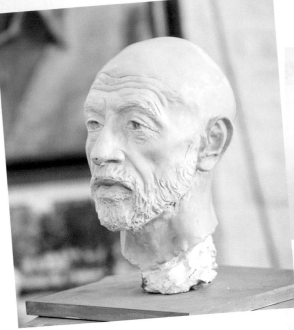

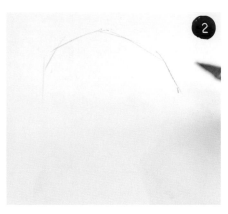

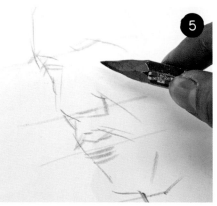

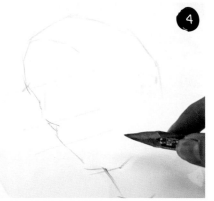

Angles

This is the method I use most for quick sketching. It is a simple procedure based on angles and distances. I break down the contours of the thing I am sketching into tilted lines.

Some people may struggle with the distance after getting the angle right. Try travelling from one point in the drawing to another in your mind, and letting your hand naturally do the same thing on the paper. You must take a tiny leap of faith at each point to believe you can get the angle and distance right each time, then do that for the next one and the next one. This is the way we learnt to walk: through faith, belief and a few stumbles – but never giving up. That's the way I go about using the angles technique.

The bust at the top of the page is a good subject to try this out on.

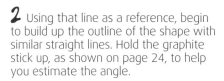

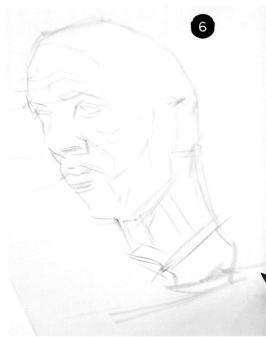

1 Starting from the top of the bust, visually cut the curve of the head into angles. Estimate the angle and distance of the top of the head, then make a single straight line.

2 Using that line as a reference, begin to build up the outline of the shape with similar straight lines. Hold the graphite stick up, as shown on page 24, to help you estimate the angle.

3 Hop from side to side of the shape to help keep things in proportion.

4 With the outline complete, add guidelines for features inside the shape – here, marks to place the facial features of mouth, nose and eyes.

5 Build up the features themselves with angular marks, using the outline and guidelines to help you.

6 With the main shape in place, you can build up some tonal work to develop the piece into a more complete sketch.

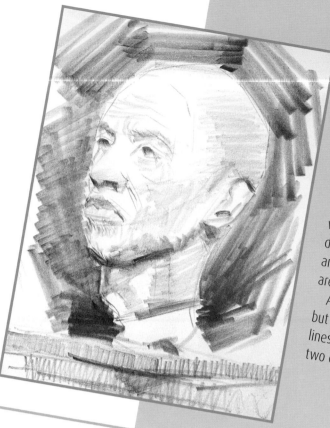

By breaking the curves of the object in front of you down to a series of matching angles, and by determining the approximate distance that each line would need to extend before moving in a different direction, you can sketch anything. The distances and angles are all taken from carefully observing what you are trying to sketch.

As an example, imagine a clock face – it is circular, but you could draw it with a series of short straight lines by placing the angles at each hour – one o'clock, two o'clock, and so on.

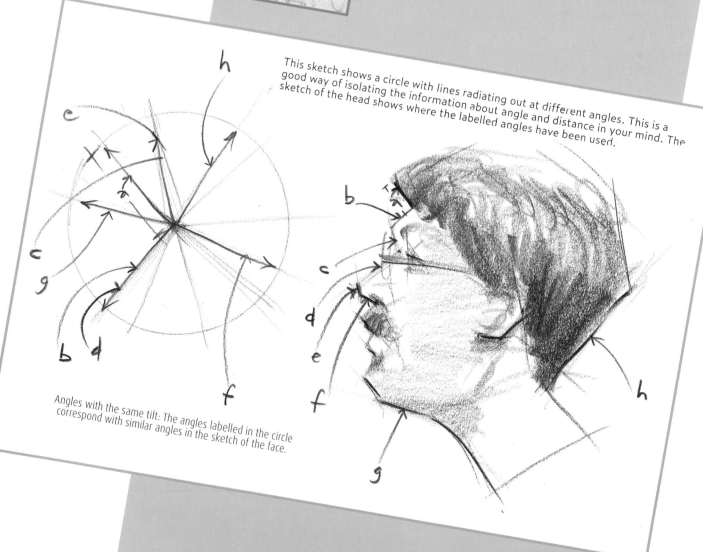

This sketch shows a circle with lines radiating out at different angles. This is a good way of isolating the information about angle and distance in your mind. The sketch of the head shows where the labelled angles have been used.

Angles with the same tilt: The angles labelled in the circle correspond with similar angles in the sketch of the face.

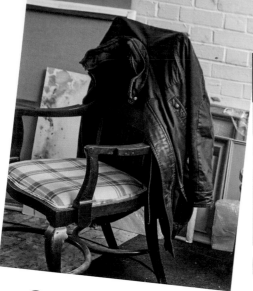

Contours

For this technique you simply travel round the contours of the subject without breaking it down into angles. This particular technique is better developed through its parent technique of 'blind contour'. This entails you looking deeply and directly at the object you are sketching and, without looking at the paper, trusting your eyes to travel round the object while your hand follows the same journey on your paper.

Give it a try now. Looking at the subject (the coat and chair above), start from one point and see if you can draw all the way back to the point you started from, making sure that you don't lift your hand off the paper, or take your eye off the subject throughout the whole drawing time. It's not going to look great or attractive but if you faithfully followed every nuance and every movement, you would have mastered contour drawing.

This exercise will help your eyes to feel the movements and your hand to follow accordingly. After a few rounds of blind contour drawing, try the exercise here, with your eyes flitting between the subject and the paper while you draw. You will see a big difference in your finished sketch.

The better your eyes and hands work together, the more they can trust each other – and the better contour drawings you will produce.

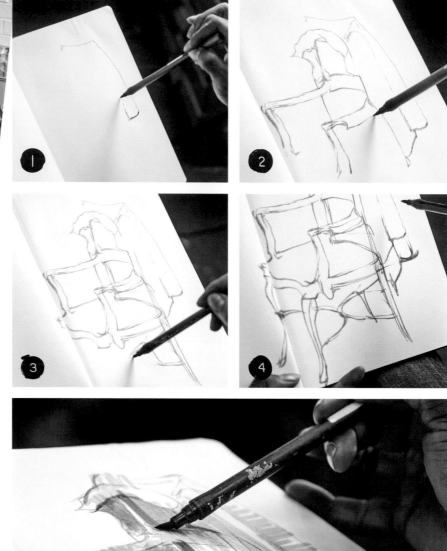

1 Holding the brush pen near the end will help to keep your touch light and loose. Follow the outline of the shape, keeping your eye on the subject.

2 Look down. Trying not to take your eye off the paper as you work, continue the line. Vary the pressure on the brush pen to change the weight of the line.

3 Look up and check for negative shapes – the shapes suggested by gaps between areas – to help draw accurately.

4 Once the shape is down, look down and correct any shapes if necessary. Just work over the existing lines again.

5 You can now shade to develop the sketch further, if you wish. Using the side of the brush pen nib will help you build up tone quickly.

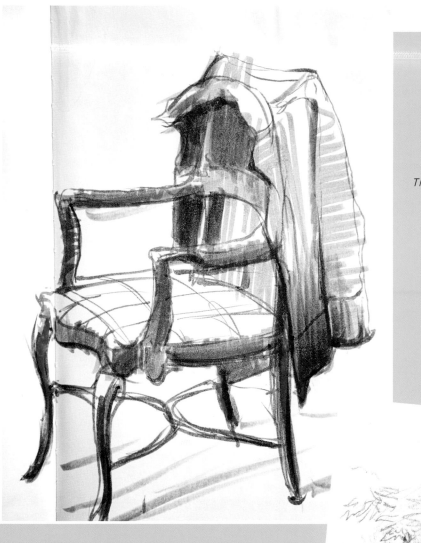

The completed contour sketch.

CONTOURS IN ACTION

To be able to sketch this bird at ZSL London Zoo I used the contour technique, and did not lift my pencil from off the paper: I simply allowed my hands to follow the movement right round the bird with a clean sweep. It wasn't easy, as the birds move a lot, but sometimes you will find one that is still and that is the moment you can pounce into action.

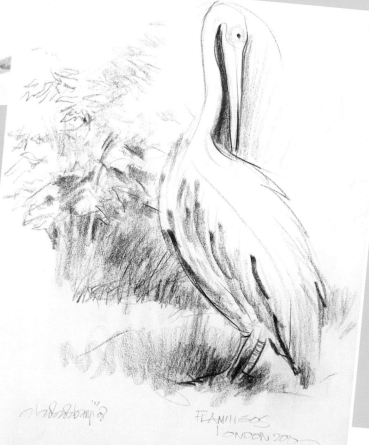

Structure

This technique of sketching involves you visualizing things as three-dimensional forms. It's being able to break down the subject into those smaller shapes, then skilfully reconstructing them to the point where the main object can then be seen. It's almost like carving an object out of stone or wood.

You must be quick to identify the bigger shapes and how they connect. Breaking complex subjects down into these simpler three-dimensional shapes is a fast way of seeing the shapes and getting the sketch done quickly.

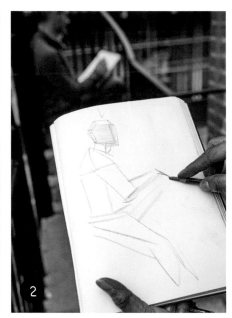

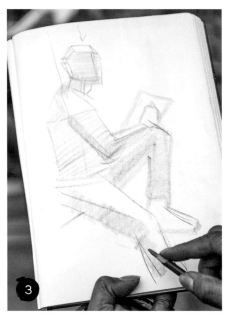

1 Begin by breaking the shape down into blocks, as though made of bricks. Start with the head, and use the pencils to shade to help you see the blocks.

2 Build up the body, connecting the new block shapes to previous parts – neck to head, shoulders to neck and so on.

3 Once the shape is complete, use the side of the pencil to add shading. This helps to make sense of the forms.

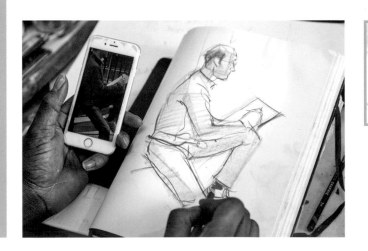

If you want to develop the sketch further later, use your smartphone to take a picture for reference details. Be polite – you'll need to use your judgement on when it's appropriate or not to take a picture of someone.

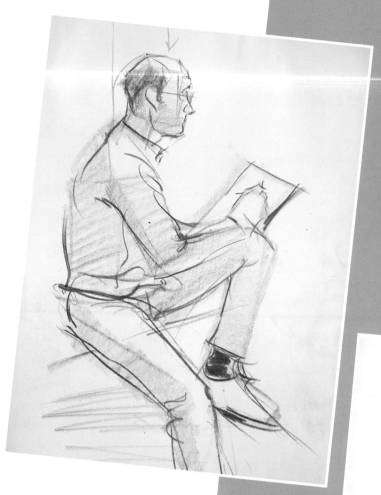

STRUCTURE IN ACTION

I use this technique a lot when trying to sketch heads as it helps establish symmetry. Each head starts out as a cube; and I then begin to chip and chop at the block until the main shape of the head and the features are formed.

STRUCTURE IN ACTION

This technique is also suitable for sketching buildings, helping you to establish the proportions of large flat spaces and make sense of more complex areas.

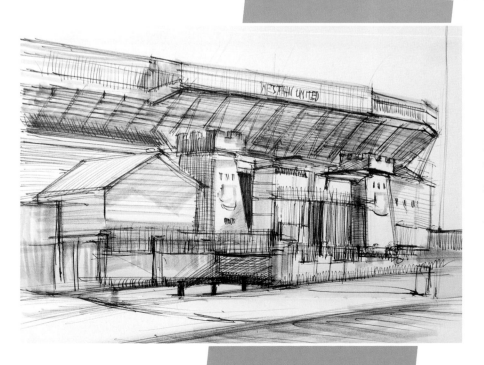

Organic lines

This particular technique is very effective when trying to capture crowds of people. It is like a glorified explosive version of the contour technique on pages 24–25, but in this case you have a network of contours that can go back and forth to create the most beautiful drawings with movement.

Using organic lines is a more hit-and-miss approach than the other techniques, and a lot of people use it because the effect is naturally very sketchy and rough. I was discouraged from using it too often by one of my tutors, who said my sketches would look more convincing with fewer lines. I focused on reducing lines and using angles mostly.

Another reason why it might not be of benefit to more experienced sketchers is that it doesn't allow as close a connection between eyes and hands; everything seems to follow an organized scribble which is rather too hit-and-miss in approach and outcome.

Nevertheless, it is a useful technique. to know – I tend to fall back on using organic lines when I am not sure of how to go about a particular sketch, or need a reliable starting point.

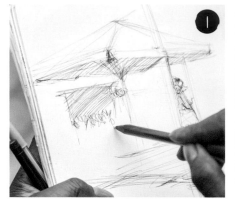

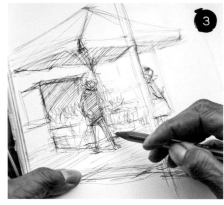

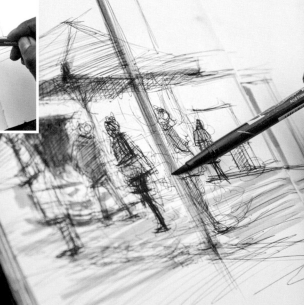

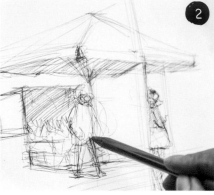

1 Use the brown ballpoint to establish an area of background first – basically, anything that won't move. With that in place, use scribbly loose lines to establish any figures as quickly as possible.

2 Move on if your subject moves. Return to the background until another figure presents itself.

3 Avoid stopping. Use flowing lines, and keep things rapid. Fill in the tone as you work.

4 To avoid the sketch becoming too confusing, you can swap colours. I used an orange ballpoint to complement the existing brown.

5 You can extend the sketch outwards from the first area of background to take in more of the surroundings if you wish – overlay existing lines if necessary; and feel free to work over the spine of your sketchbook: enjoy yourself!

6 Swap to the dual wash pens to add some tone and colour to the sketch.

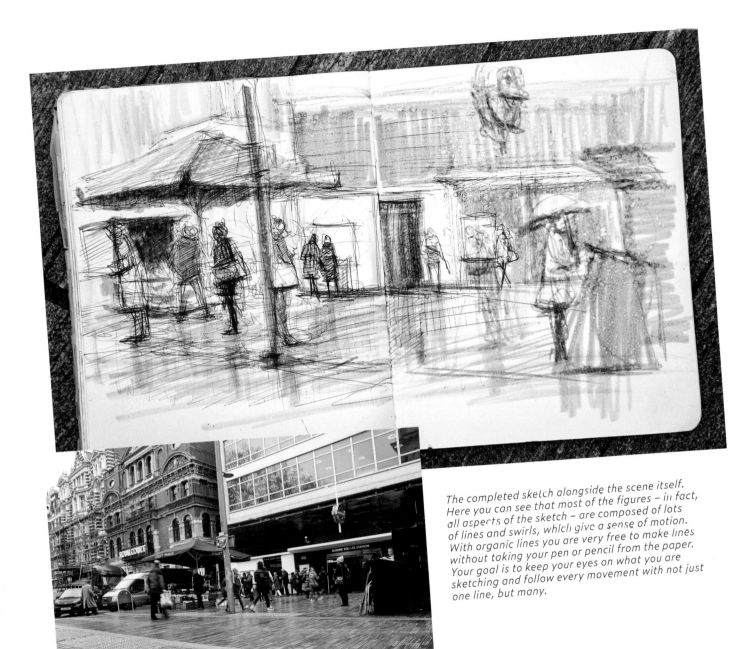

The completed sketch alongside the scene itself.
Here you can see that most of the figures – in fact,
all aspects of the sketch – are composed of lots
of lines and swirls, which give a sense of motion.
With organic lines you are very free to make lines
without taking your pen or pencil from the paper.
Your goal is to keep your eyes on what you are
sketching and follow every movement with not just
one line, but many.

Ghosting

This technique is useful for sketching anything that has large areas of dark- and mid-tone masses. The main goal is to quickly block in these dark and middle tones and then use an eraser to remove or take out highlights. After this is done, you can add details with a pencil. I normally use charcoal dust and water for the broad masses and then use an electric eraser to take out the highlights before adding finishing details using an oil-based pencil. Because oil doesn't mix with water, you can go back with darks if there are some areas that need touching up.

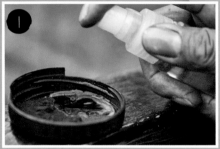

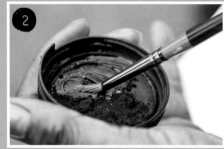

1 Wet the lid of your charcoal pot with water spray.

2 Mix charcoal dust into the water with a brush. I'm using a size 6 round brush.

3 Working in the direction of growth – that is, upwards from the ground – establish the trunk.

4 Use short, choppy marks outwards from the trunk to sketch in the mass of foliage, adding more water to your mix to create a lighter tint and vary the tone. The ghostly, part-seen marks are what give the technique its name.

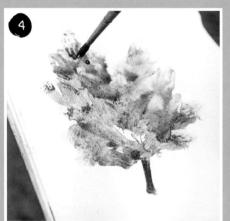

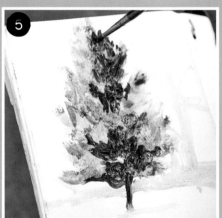

5 Add darker areas using a mix strengthened by adding more charcoal.

6 Once dry, work over the sketch with oil pencil to create more definition on the trunk. Keep looking at the tree in front of you as you add branches.

7 You can add more detail with a small brush and charcoal, working over the oil pencils. Water and oil don't mix, so oil pencils work well over the top of the charcoal and water mix for this technique.

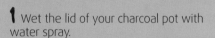

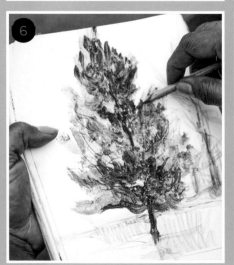

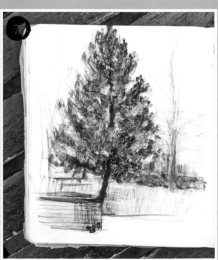

THE GHOSTING TECHNIQUE IN ACTION

The whole sketch was first smudged in with charcoal dust, the lines were then added with an oil pencil, and the highlights were taken out with an eraser to achieve the final effect, shown to the right.

Below you can see an oil painting I worked up using the sketch as reference. Having a good, accurate sketch is important to getting good results in any later painting, should you decide to do so.

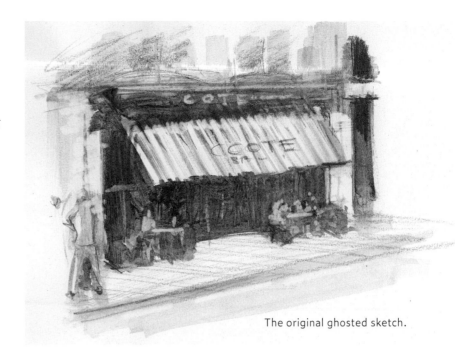

The original ghosted sketch.

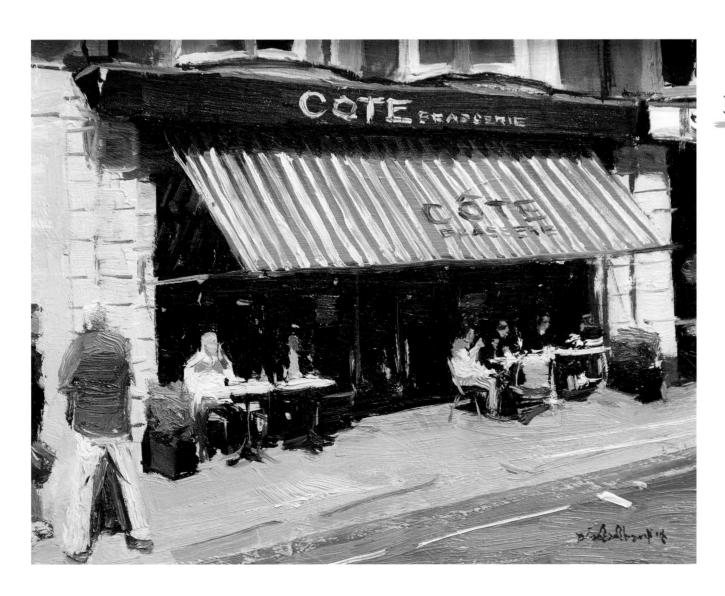

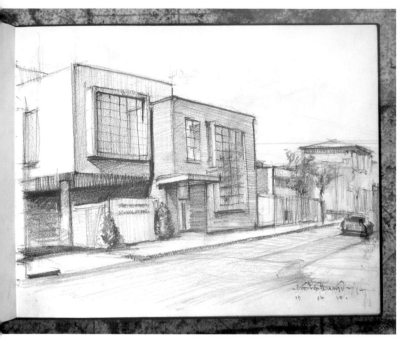

Matching subject to technique

It is important to remember that any subject can be tackled using any technique or combination of techniques. With that said, some techniques lend themselves to particular subjects. For example, organic lines work nicely for crowds of people because the technique is quick and loose, allowing you to rough in lots of lines from which you can then choose. It's a good technique to suggest the movement and mass of groups.

I've picked a few sketches here to show some an example of a subject particularly well-suited to each technique – use these ideas as a springboard.

Angles: Heatherley School of Fine Art

The strong, obvious lines of modern architecture means the angles technique works well. Most of the lines here were at similar angles or parallel to one another – by making sure one gets the right angle at first, everything falls into place. I worked with graphite for this example.

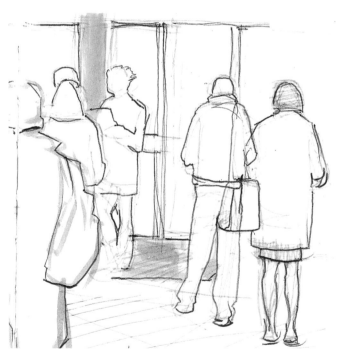

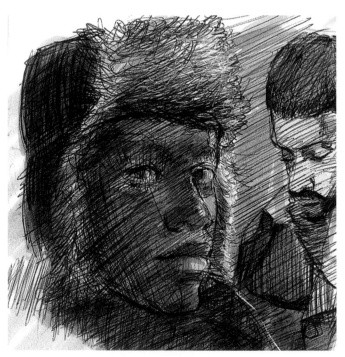

Contours: Belvedere railway station during delays

You notice the figures here are all outlined in ballpoint pen, without any tone. The contour technique is good for quick work on crowds. Here, I made sure that I followed every nuance as I went along, moving and flowing from one figure to another in a continous stream.

Structure: Head in brown ink

For this sculptural head, I sketched using the felt-tip end of a dual wash marker, and used the brush end for the tonal wash. Everything here is based on the cube. Seeing the head in terms of a cube helps define the structure quickly, which invariably helps with the sketch.

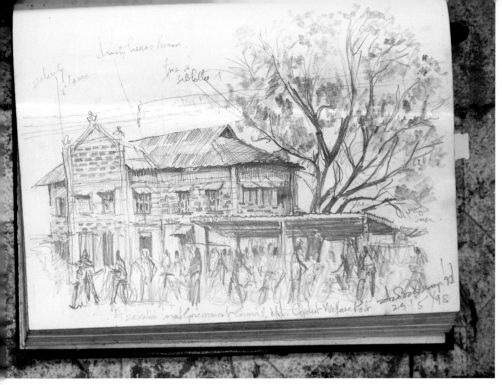

Organic lines: Abakaliki motorcyclist welfare post

At this cyclist stop, there were a lot of people under the shed – so many that I couldn't get them all in accurately due to their movement and number. To get anything close to what I saw, I worked with several lines, going back and forth in a circular manner and following the contours of the many figures in the area. You will notice that some figures are more detailed than others.

The results of using this technique are always interesting: the scene always looks alive and dynamic due to the number of lines involved.

Ghosting: Josh in Sleep Mode

Here I worked with sanguine and sepia dust for the broad masses, before sketching in Josh's main features with lines using an oil pencil. Finally I used an eraser to take out the highlights to give the figure a more three-dimensional presence. This technique is perfect for sketches where you have the time for more consideration.

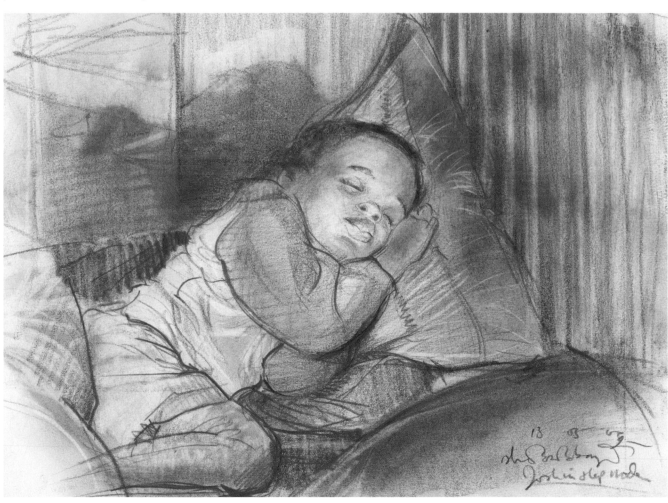

COMPOSITION

The fourteen key words below represent everything I know about composing a painting, and they also apply to sketching. Seven of them are principles that will come in handy time and time again, while the other seven are the marks that make for successful composition. The simple definitions here will make them easy to understand – and then, whenever you paint, you can check your work to see whether the results show these principles.

Ignoring the ingredients for a cake recipe will result in a bad cake. It is the same with composition: if the elements and principles here are disregarded, the consequence will be a bad design.

Principles

UNITY A painting with a feeling of togetherness demonstrates unity. The colours feel related and the overall feel of the painting works. There are no jarring aspects.

CONTRAST If a painting does not have enough contrast, it will fail to create the illusion of a three-dimensional representation on a two-dimensional surface. The greater the difference between the light and dark tones in a painting, the greater the contrast.

DOMINANCE When the colour, the tone or one of the major elements in a painting has at least sixty per cent of the picture, it is said to dominate. Every successful painting has a dominant, eye-catching feature of some sort. If all the tones are equal or colours are all over the place, with no fusion, then it has failed big-time.

REPETITION Whether it is the brushstrokes, the shapes or any of the main elements in a picture, some parts must reoccur in the painting. This helps to give the painting a sense of synchronity and rhythm.

HARMONY A harmonious painting occurs when there's a delightful relationship within the painting as a whole. This is mainly seen in the choice of colours and the light that is the main feature in the piece.

BALANCE When all the elements in a painting are distributed evenly, it is said to be balanced.

GRADATION A gradual change from one state to another; gradation should happen in some point in the picture. This might be a gradual increase in tone, in the intensity of a colour, or in aerial or linear perspective: things getting smaller as they gradually fade into the distance is an example of gradation.

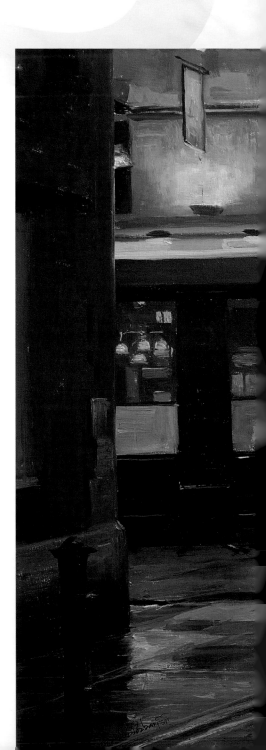

Marks

LINE These are the marks that connect points in the painting together in a continuous flow.

SHAPE These are the small or large spaces – both negative and positive – that make up the picture like a jigsaw puzzle.

TEXTURE The marks that cause part of the flat surface of the picture to appear either raised or cut into.

SIZE The absolute and relative size of marks is an important factor that must be thought about even before embarking on the painting.

TONE All marks have tone, which should contrast with the background on which they are made – light marks on dark areas; dark marks on light – in order to be visible.

COLOUR Every mark on the painting will also have colour, which is a combination of tone, hue, intensity and temperature. Each one of these characteristics can influence the composition of the work, so great thought must be put into the choice of colour you use for a mark, and how that affects the elements that surround it.

DIRECTION The direction – horizontal, vertical, diagonal – of individual marks must lead the viewer around and within the painting, not out of it. In addition, there should be a general thrust as to where the painting leads and where the majority of marks point. This could be from the back to the front or vice versa. A successful painting will have a prevailing passage or angle that holds everything up as one.

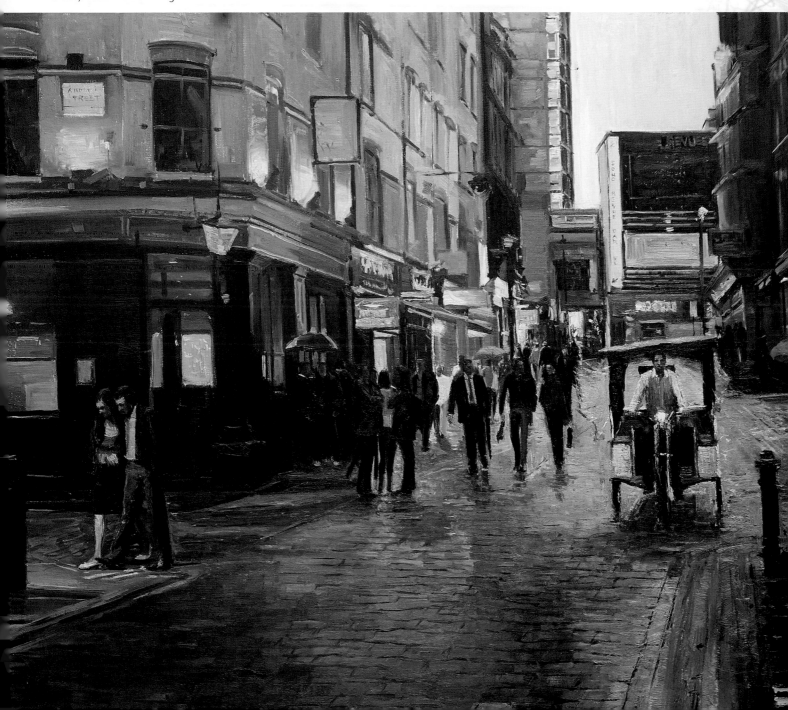

Compositional pointers

Composition is the second most important element in a painting, with drawing being the first and colour third. All the refined sketching skills and dexterity of technique in the world won't save a bad composition – it will all come tumbling down. The examples on this page give you some basic guidelines that I would like you to follow.

Being able to lay out a picture to have the elements and principles explained on the previous pages is what composition is about. I see them as laws we have to choose to obey in making our drawings and paintings pleasant as a whole. Nothing is separate in the picture. Everything must work together!

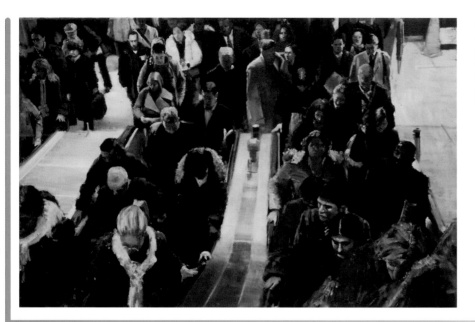

Rush Hour IV
This is all based on the beauty of unequal parts. The unequal distribution of light and shade makes this composition work. If you squint, you'll see that the overall dark shape 'plugs into' the light shapes, but the darks are dominant.

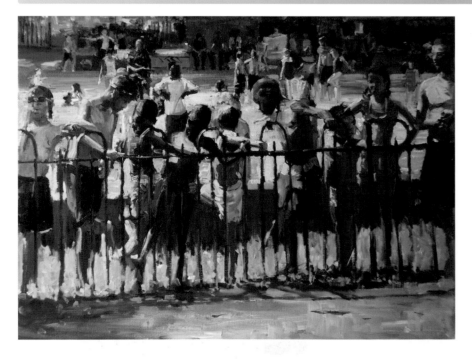

Summer Light, Clapham Common
The composition here is complex and based on overlapping strips of light and dark tones. One strip is dominant, the rest equal. If you squint, you will notice a dark strip at the top, which is the background with the onlookers. The light strip underneath this is the water, which is dominant; the third strip is the dark wall, the fourth strip is the light grass and finally the fifth strip is the dark pavement. The interplay of horizontal light and dark strips makes the work interesting.

DYNAMIC BALANCE

Whatever else I am doing while composing a painting, I always make sure it breaks the rules of equals. Everything has to end up in an unequal balance, with something as the superstar and the other elements the supporting actors.

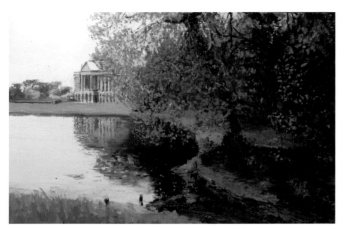

The tree here is the main element. It fills up the bulk of this painting, while the other elements are there to support it with unequal balance.

STICK TO THE STORY

If my painting is based on a narrative, I make sure that I never lose sight of that, so that the story comes out clearly in the finished piece.

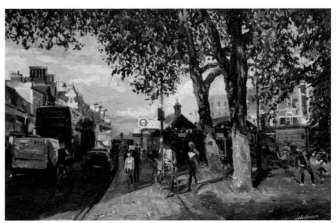

This piece was based on the beauty of the evening light and shadows. Whether cool or warm, I made sure that those shadows played their role right until the end; even though there were other distracting elements in the painting.

TAKE ANOTHER LOOK

Where possible, I occasionally turn the painting upside-down when composing, as this helps make it look unfamiliar and abstract, which in turn can help you identify a successful value pattern. Some call this value pattern *notan*, a Japanese term for the balance of dark and light. It is so important: if you get a good abstract pattern in the beginning, the painting will hold together if all else fails.

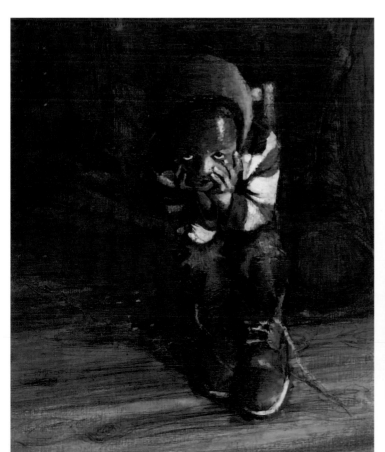

The Hangover

The original makes for an interesting design because of the unequal distribution of light and shade. The version below, upside-down and reduced to simple tones, shows this distribution.

KEEP THE EYE IN THE PICTURE

I do my best not to put anything in the corners as drawing the viewer's eye here leads the viewer out of the painting.

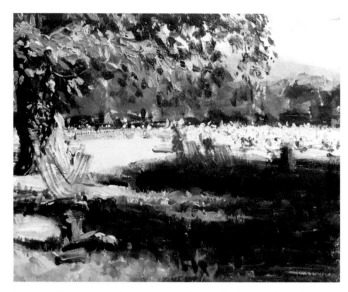

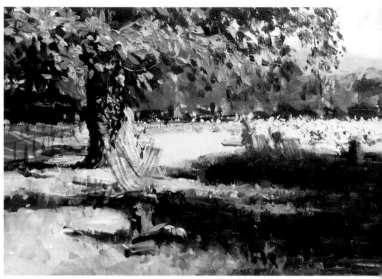

Wrong: The tree, at the extreme left-hand edge of the painting, draws the eye and leads it out of the picture.

Correct: The tree is no longer at the end, but within the picture, encouraging the viewer's eye to wander through the picture, not out of it.

OFFSET THE FOCAL POINT

I try not to place the main subject, or the largest object in the painting, in the dead centre. Doing so has the effect of dividing the picture into two equal areas, which forces the viewer to choose between them - the eye flicks back and forth, not settling. The experience is unsatisfying. Give the viewer a larger and smaller side, as this gives them an obvious path into the painting, and leads them through it.

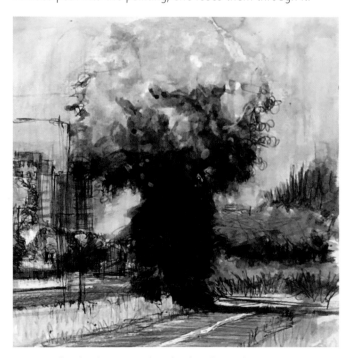

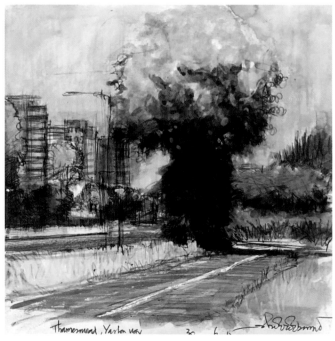

Wrong: The dominant tree breaks the picture in two equal halves.

Correct: Here the tree is slightly off-centre, to create a more interesting composition.

UNEVEN HORIZONS

Putting the eye level in the middle of the picture divides the picture into two equal parts, which looks solid, dull and lacks motion. Setting it slightly above or below the halfway line creates dynamism.

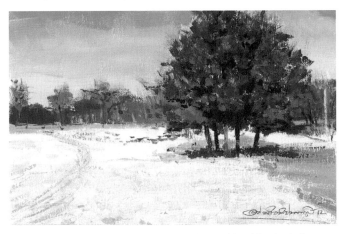

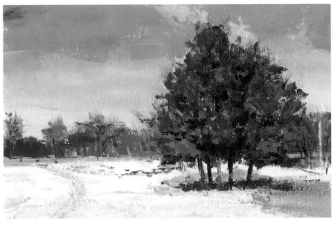

Wrong: The equal balance between sky and land looks dull.

Correct: The horizon here is lower, creating more sky and less land. This creates a more interesting composition.

UNBALANCED SPLIT

A similar principle to offsetting the focal point, placing objects two-thirds or three-quarters of the way along the horizontal or the vertical plane will divide the picture plane unequally, creating a more interesting composition that placing them equal distances from the corners.

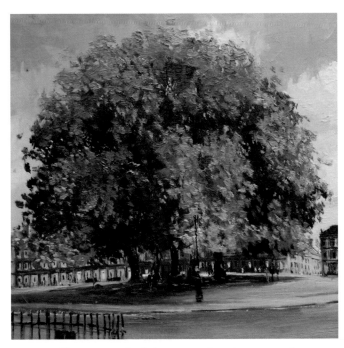

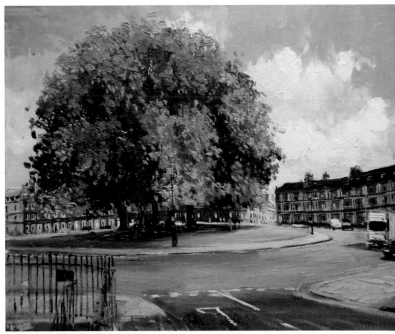

Wrong: Filling too much of the space, there is no room for complementary areas.

Correct: Here more space is given around the tree; it is not just plunged into the middle of the painting. The top of the road also runs horizontally along the top of the lower third of the painting.

Perspective

'If the intent of a drawing is solely to show off perspective knowledge, that ego will be there, fused with every line, vulnerable to discovery by an astute observer. If perspective is part of the beauty the artist wants to convey, then that too will be apparent.'

Sherrie McGraw, *The Language of Drawing*

With these words, I would like to open my relationship with perspective. While in school, my best subjects were technical drawing and fine art. I thought I was going to be an architect back then, because I loved – really loved – technical drawing. Today, though I still make my living through my technical drawing skills, my goal is to make sure I don't bring all that measured life into my art world, which I love to keep free! So, while I still love the technical depth of perspective, I don't make it the sole energy behind my work.

When working on architecture or interiors, I bear in mind the spirit behind perspective. At its simplest, the main thing to remember is that objects recede with distance, and much can be achieved with observation over theory. Within a few moments of looking closely at an object or a street, it becomes clear which directions the main lines are tilting towards and the directions in which the angles should go. This is as far as I tend to go.

At is most basic, perspective is your tool to help you represent the three-dimensional point of view in front of you on the two-dimensional surface of the page. If you are starting out, it is good to be aware of two important kinds of perspective you will see while sketching: aerial or atmospheric perspective and linear perspective.

AERIAL PERSPECTIVE

Also sometimes called atmospheric perspective, the basic principle behind this is that colours in the distance appear cooler and greyer than those that are nearer, which will be warmer and more intense. This depends on the scene in front of you and cannot always be treated as a hard-and-fast rule, but is good to know about.

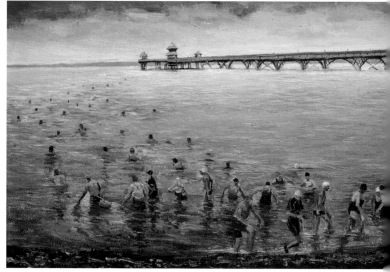

The paintings here show some examples of aerial perspective. Note how the horizon line is softer, cooler and bluer than the foreground in each.

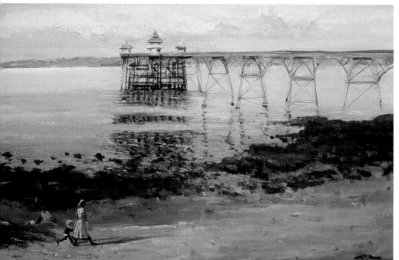

While a student at Heatherleys, one of my tutors said to me, 'If you see an angle and you want to get it right, hold it up to copy the angle you are looking at, then take that same angle and draw it on your canvas or surface.' I have always done that since and it's helped me simplify perspective.

LINEAR PERSPECTIVE

Imagine a box in front of you. Linear perspective involves imagining a series of lines that extend from the box and converge on one or more points on the horizon. The most common perspectives I encounter while sketching are one-point perspective and two-point perspective.

The main difference between one-point and two-point perspective depends on where you stand in relation to what you are sketching or painting. In one-point perspective the viewer is looking directly at the front plane of the imaginary box. This is known as 'front plane view' or the 'elevation view'. The eye level is perpendicular to the front of the box.

The sides of the box appear to angle towards one vanishing point, marked by the converging diagonal lines. These diagonal lines can be used as reference to work out where and how to place other objects.

In two-point perspective, the viewer is positioned in such a way that they can see two sides of the box from the corner. Each side recedes into the distance, each with its own vanishing point as seen in the illustration. Both vanishing points remain on the eye level.

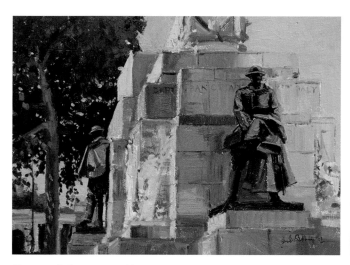
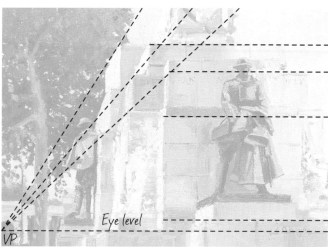

One-point perspective

In this example, the front of the monument is face on to the viewer. The lines here remain parallel. As the side of the monument gets futher away, it recedes. You can see the lines converging towards a vanishing point (VP) on the eye level. The eye level is deliberately very low here, in order to give a suitably monumental sense of size to the war memorial.

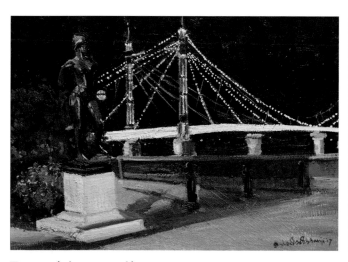
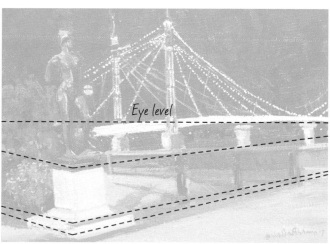

Two-point perspective

Here the eye level is more conventional. With two sides of the statue's pedestal visible, there are two sets of receding lines – and thus two vanishing points. Both are off the sides of the image, but we can still use them to help us plot the shape and size of the objects in the picture.

VALUE & COLOUR

Value

Value, or what we sometimes call tone, is how light or dark something is. Value is more important than colour. If we can get a sketch or painting to have a great value pattern that is abstractly interesting and sits within the parameters of a great design, then our colours will just be the icing on the cake. The real deal is the value pattern.

It's good to have a dominant value in a painting. It should be dominantly light, middle-toned or dark. This will help it work as a successful design plan. Whenever we sketch or paint, we should always do a thumbnail sketch or design plan in just three tones and simplify the whole scene to see if it looks interesting. If it does, the painting will work.

When we paint and sketch we sometimes lay down a powerful design plan without properly considering a value plan. From experience I know that every painting or drawing for which I thoroughly plan the values is always successful! The painting opposite is a good example. Look at the value pattern; it works because that simple tonal study (at the top) was successful.

Remember what makes a value pattern interesting: the use of one dominant value. In the example on this page, the dominant tone is dark: there are more dark tones than mid or light tones. The other tones are also unequal with each other, and both are in smaller amounts compared with the dominant tone.

Tonal range

We can get at least nine different ranges of lightness to darkness in a single picture. Anything more than this is a bit too much for a sketch. Even for more polished paintings, you only really need about five tones for a particular piece to be successful. The details below show a range of values used in the sketch above, ranging from very light on the left to very dark on the right.

This sketch ranges from very light tones – the unmarked surface of the paper on the figure's shoulders – to very dark. The contrast between the deep shadows near her cuffs and her white clothing is very strong, drawing the eye. Softer tonal transitions are apparent in her hair, which ranges from very light highlights, through warm midtones to deep shadows.

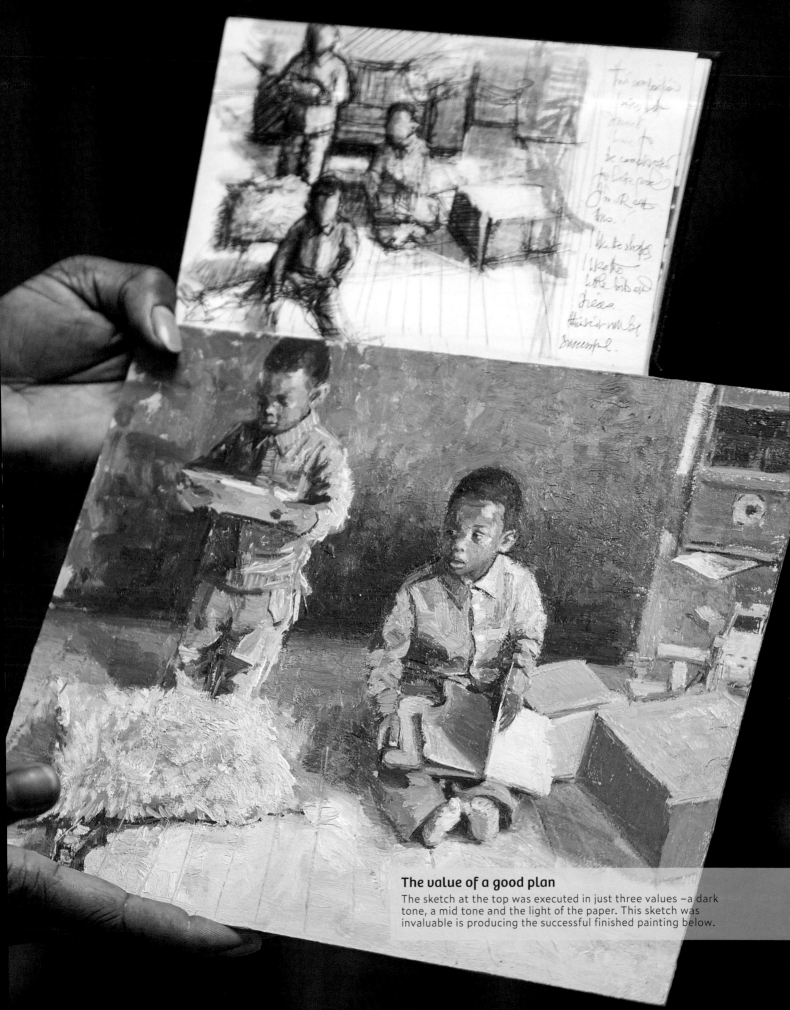

The value of a good plan

The sketch at the top was executed in just three values –a dark tone, a mid tone and the light of the paper. This sketch was invaluable is producing the successful finished painting below.

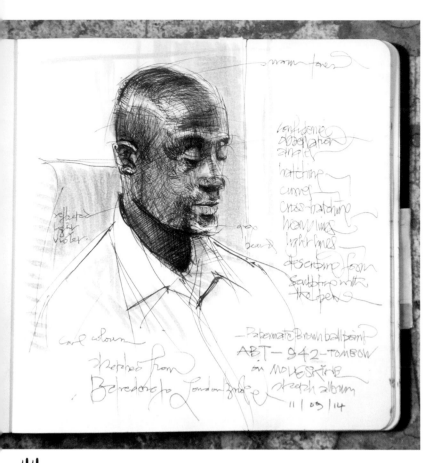

LIGHT AND VALUE

What determines value is the effect of light on any particular object or scene. When sketching, remember the following six kinds of light, and work out which type is hitting the part of the subject you are sketching:

Highlight This is a bright spot that directly reflects the light source. It will give you your lightest values.

Middle tone Light that hits the object at an angle from the light source will be partly in shadow, so not so bright as the highlights.

Dark This is the effect of the absence of light on a particular surface. It gives you your darkest values.

Light The light that hits the object directly from the light source. This helps you establish your basic values.

Cast shadow This is the effect of the absence of light on a surface caused by another object between the light source and the surface, blocking the light.

Reflected light This is the light that bounces off another surface onto an object. It usually shows up near the shadow of the object.

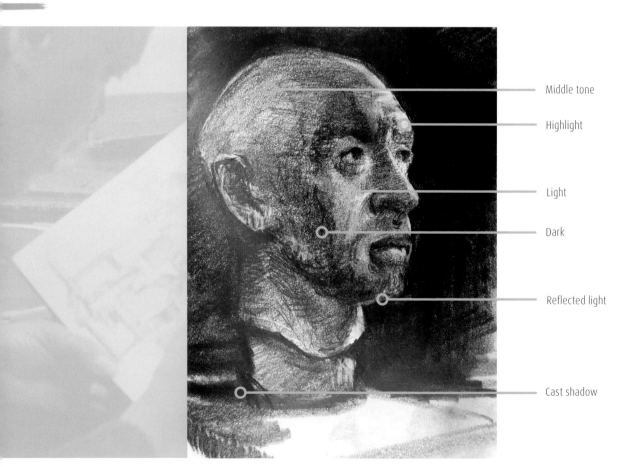

Middle tone

Highlight

Light

Dark

Reflected light

Cast shadow

Colour

Colour is judged only from observation, so when sketching I follow the natural colours I see. With that said, whenever I complete a picture in colour I make sure to go back and tie everything together so that it works as a picture. I simplify my colour choices and what I do with colour to the following three factors.

Hue The local or source colour of what I am seeing. I have to make this choice first. For instance, if I wanted to sketch a carrot in colour, its hue would be orange: so that's my first choice.

Value As explained earlier, this is how light or dark something is. In the case of the carrot, I would like to know how dark or how light it is in relation to the light source.

Temperature This is how cool or how warm the carrot appears in the light that affects it – objects closer up, or during the middle of the day, tend to appear warmer than more distant objects, or those in early morning or late evening, which appear cooler. I'll ask myself whether I need a cool orange or a warm orange paint or pencil based on this factor.

I usually limit myself to these three factors for sketching as these basics allow me to work quickly. I can make all the necessary adjustments by following just these three factors. There are others, however. For example, another important thing that I might consider is to ensure that one colour is dominant: *San Francisco Blues* is predominantly blue, for example, while *Kezia Painting* (see page 125) is predominantly reddish-brown.

Colour harmony can also be considered. This really comes into play with the kind of light that affects whatever we plan to paint or sketch. My basic way of achieving harmony is to find whether the light is cool or warm. If it is cool, the shadows in the painting will be warm, while if the light is warm, then the shadows will be cool. This instantly helps harmonize most of what I paint or sketch in the simplest form.

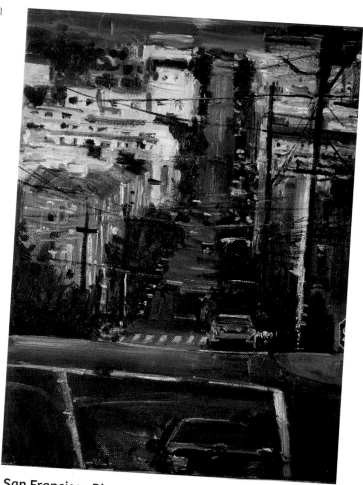

San Francisco Blues

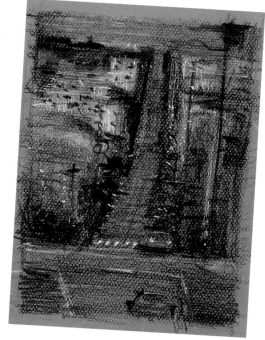

Tonal plan for the painting above, made using coloured pencil and white ink.

PEOPLE INDOORS

Most of us spend more time indoors than out, so believe it when I say we'll be able to get lots of sketches done of people indoors. In fact, this is the best place to start to use your sketchbook. You can sketch the people you work with, people in your family, your friends, fellow students – in fact, anyone you spend time with. One thing that helps sketching people indoors is familiarity. You can ask friends and colleagues to hold a pose if you think that would help, but the most important thing is to catch people in their environment and quickly sketch them right there and then.

I use all the techniques described earlier when sketching people indoors, but my most treasured one is angles (see pages 22–23), because I tend to see outlines and the contours of objects in terms of angles. This must have come from my love for technical drawing. Most artists fall back on the particular technique that they feel most comfortable using.

My key advice is to always have your sketchbook handy wherever you are and once you see something that catches your attention, just start sketching. Remember, don't aim for perfection: go for what excites you – and develop a habit of constantly doing it.

Home

I encourage you to make your sketchbook a member of your family, and make sure the people in your family know there is another member who is always present. Use your sketchbook to the point where, if you don't use it, the family wants to find out why you haven't sketched today.

Where and how to start? I encourage you to start from the sitting room, where everyone is relaxed watching television, reading a book or magazine, or sitting addicted to their smartphone or tablets. This is the time to bring out your sketchbook and become addicted too!

When my children were younger I was more of a 'stay at home, work from home' dad, so I sketched them to keep up with my habit when I was using public transport less frequently. The subjects I used to do much more than any other were my kids sleeping, as you can see in *Josh in Sleep Mode*, on the facing page.

My main advice here is this: get into that sketching habit right from home and make sure you seize precious moments. It may be your partner or sibling asleep on the couch, or your flatmate cooking. Sketch, sketch, sketch, draw, draw, draw. Never should you allow such moments to pass you by; they are precious moments that need to be recorded. Why? You are improving your drawing skills, and you are becoming more familiar with everything you sketch. You never know something well until you have sketched or painted it. This practice at home will also make a great family journal or album in years to come, to be cherished and valued even more than photographs.

These reasons all matter, but nothing beats the real purpose: because you are an addictive sketcher, and you are constantly sketching your world for the sheer love of sketching – it's a good thing!

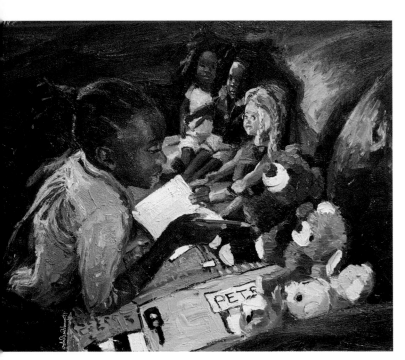

Spirit of Togetherness
I planned this painting from sketches and photographs taken while my daughter played with her dolls.

The goal is to seize every moment and make them count. At home, right under your nose, there are treasures to bring to life everywhere. Just open your eyes.

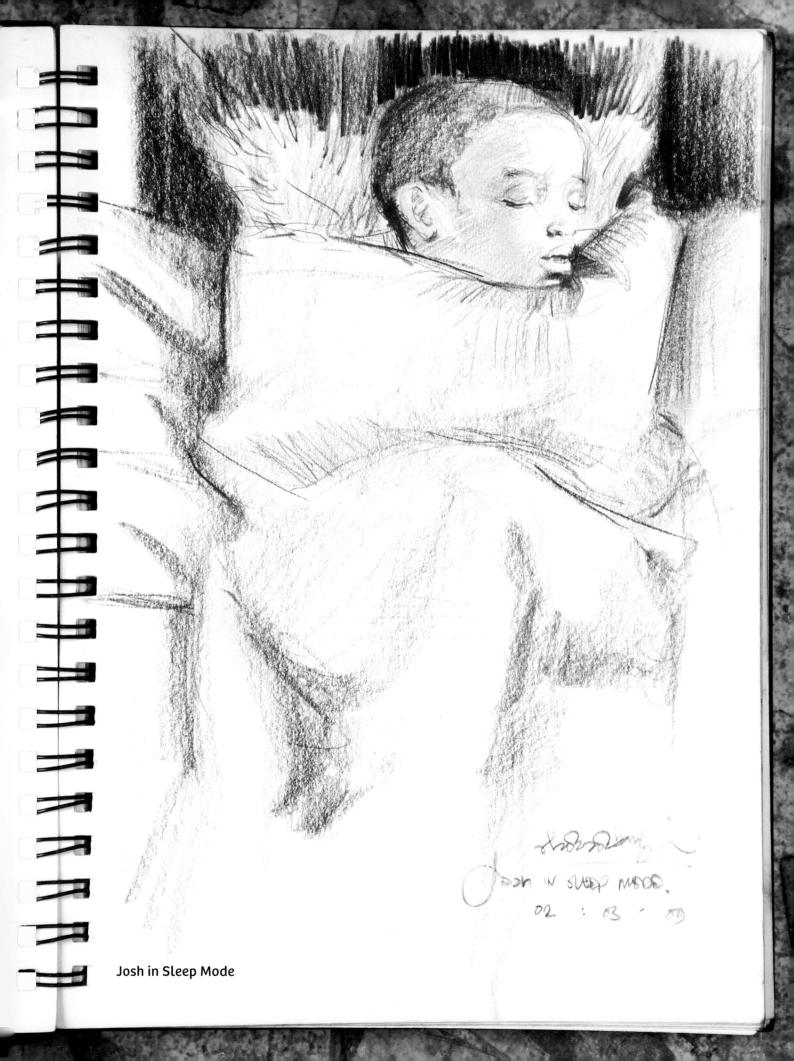

Josh in Sleep Mode

School and work

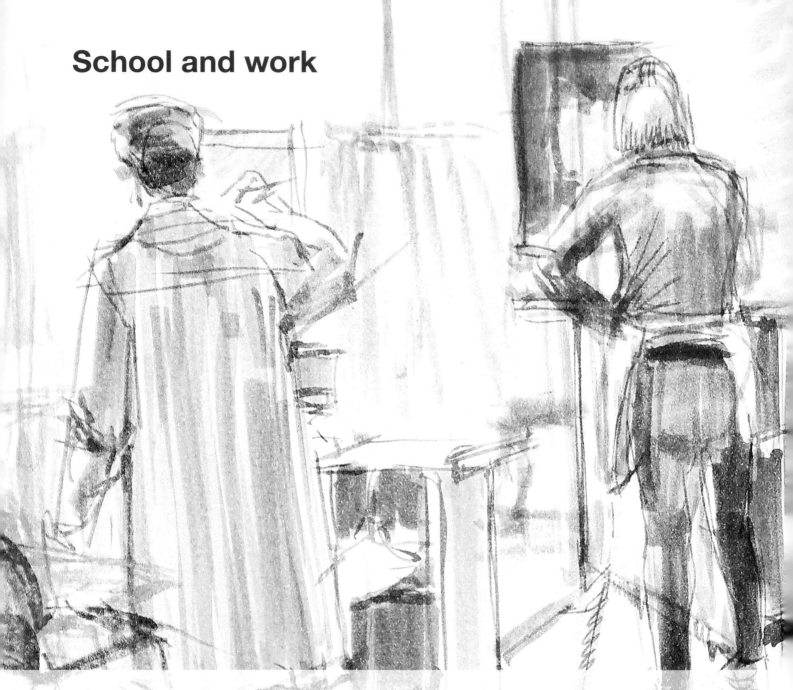

At school and work, there are always going to be great times to sketch. At break time, when others are hanging out and having lunch, what does the addictive sketcher do? We quickly finish our lunch, find a nice spot and just start to sketch. I even sketch during meetings – but secretly, to avoid being tagged as 'unserious'.

Other space that can be used where people are relaxed include the library, the staff room or the common room. By constantly sketching, you will build up a whole repertoire of scenes in your creative bank. They will come in handy if you are a figurative painter, illustrator or animator. The key is to make the simplest and most unassuming of places – like the launderette – sanctuaries of art. Ultimately there should be no place that you go to where your sketchbook is out of bounds.

Train yourself to be constantly looking for opportunities. That is part of the joy – you must be alert.

Always have your sketchbook accompany you. Once it becomes your companion and second nature to you, you will never lack ideas of what to paint because you have sketched so many different places. Your sketchbook will become a creative library of ideas and possibilities. These are the things that keep me sketching; it's a non-stop process! Are you still in this game with me?

This page:

I teach at Heatherley School of Fine Art, and here I used angles with dual wash markers to quickly sketch Erika and Krystina at work in the Open Studio. I used the thin tip of the marker for the lines and the brush tip for the tones.

I went to the launderette at Chelsea on Kings Road. From the side where the washing machines were I saw a lady at a machine, mending and putting in adjustments to clothes. I sketched her using a ballpoint pen and the angles technique, because that made it easiest for me to understand all the movements and changes in directions of the lines and shapes.

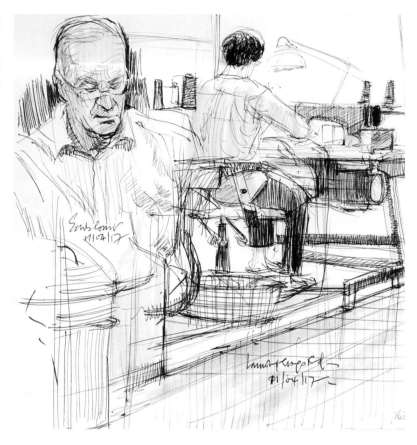

Below are two sketches made on a trip to Japan. On the left is one of singers at a Christmas concert at Okura Hotel; the other is of a figure at Narita airport. Both were done in graphite with angles.

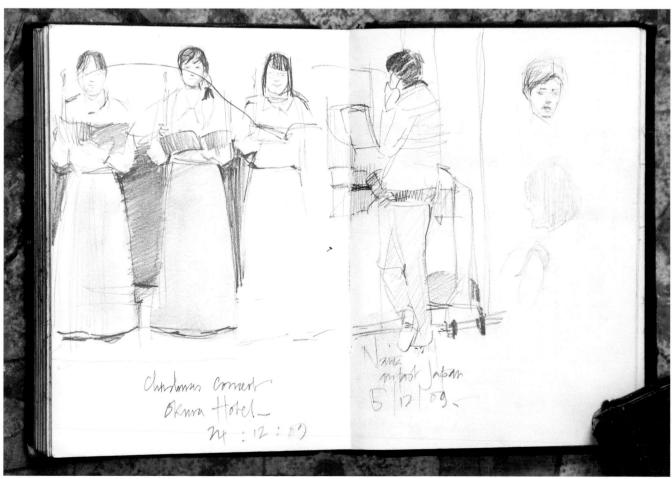

Bars, cafés and pubs

England is a wonderful place, where almost every street has a local pub or café. Just look anywhere in one of these settings and you will find people relaxed and sharing their time together. That's a sketching hot spot. My main strategy to start off is to make a very rough thumbnail of the whole scene. It's with this thumbnail that I gauge what might work out; what would look interesting. I can then focus on that.

How do I go about starting to sketch in these settings? I go straight into the café or pub and make sure I order a drink (I love sparkling water with lemonade), then find a good spot where I can see both the people and a bit of the lovely interior atmosphere. Then I simply start sketching. Sometimes I ask whether it is okay to stay in the first place, but sometimes I just go along and can't be bothered – I just get on with it. Later on, when the waiter or waitress comes over, they see it and they almost always are delighted to have been sketched.

Sometimes I get an extra drink or a meal from them – all because I've decided to sketch in their bar or restaurant. You might be lucky too: the pub or the restaurant might even buy the sketch or commission you to do a finished piece.

I once forgot my sketchbook in a café. The owners called me (another reason to always put your contact details on your sketchbook) and invited me to have lunch for two on them. Tell me, doesn't addictive sketching pay off?

The main thing to remember is to make any indoor space a haven where you can explore the possibilities of sketching people in different settings. If you are into figurative compositions or illustrations, this habit will fill you with an endless stream of ideas and possibilities. You will also have lots of reference material to help you with different situations and scenarios where you might need to depict people in these kinds of places.

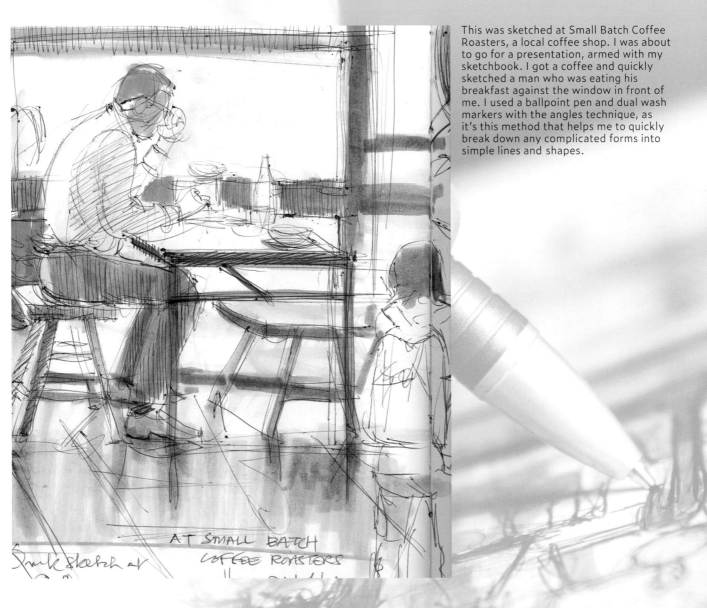

This was sketched at Small Batch Coffee Roasters, a local coffee shop. I was about to go for a presentation, armed with my sketchbook. I got a coffee and quickly sketched a man who was eating his breakfast against the window in front of me. I used a ballpoint pen and dual wash markers with the angles technique, as it's this method that helps me to quickly break down any complicated forms into simple lines and shapes.

AT SMALL BATCH COFFEE ROASTERS

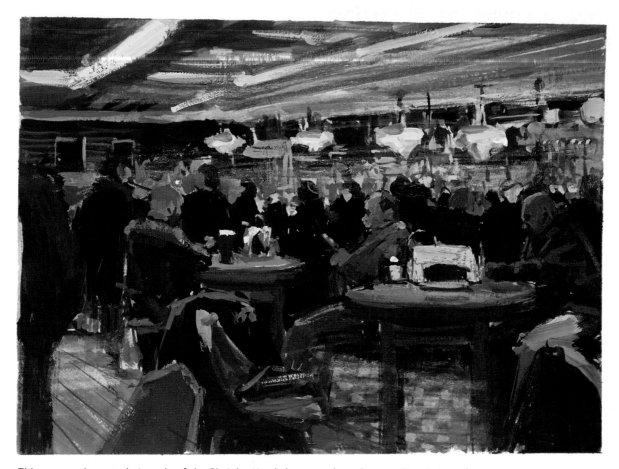

This was a colour study I made of the Sir John Hawkshaw, a pub on Cannon Street. I used gouache, dual wash markers and coloured pencils – I often combine media to get quick effects which might not be possible with one medium. Below you can see an initial value version I sketched beforehand, using just one coloured pencil.

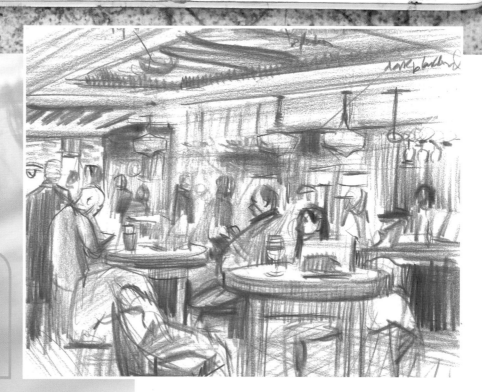

If you feel timid or nervous about going into pubs or cafés alone to sketch, go with a friend and start sketching them. You can then add others, and as you go along you'll fill up the whole scene.

Public transport

I use trains and buses a lot to commute between my studio in Chelsea, London, and my home in Kent. Without sketching on those journeys, it would be a waste of creative time. I spend close to four hours when travelling, and have filled loads of sketchbooks doing so. It makes the journeys worthwhile.

Public transport is where I do about two-thirds of my sketching. Nowhere else has afforded me such a mix of people from different places, countries, different moods, different clothes. The variety is endless. As you can see from the illustrations here and throughout the book, my main aim on public transport is not to produce finished sketches, but to keep training my eyes and hands to become better friends. It is public transport that has allowed me to train myself to become a better sketcher.

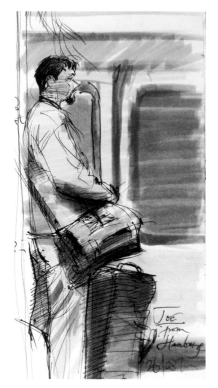

These page show the typical way I sketch commuters on public transport. In many cases, the whole page is covered with overlapping sketches. I mostly use a combination of ballpoint pens with dual wash markers. I never let a moment pass once I'm on public transport; every face is interesting, and everybody captures my attention. Whether they are reading, browsing, sleeping or snoring, nothing misses my curious eye. On each page I normally make a note of the station at which I start, and the station where I finish, along with the date on which I sketched it.

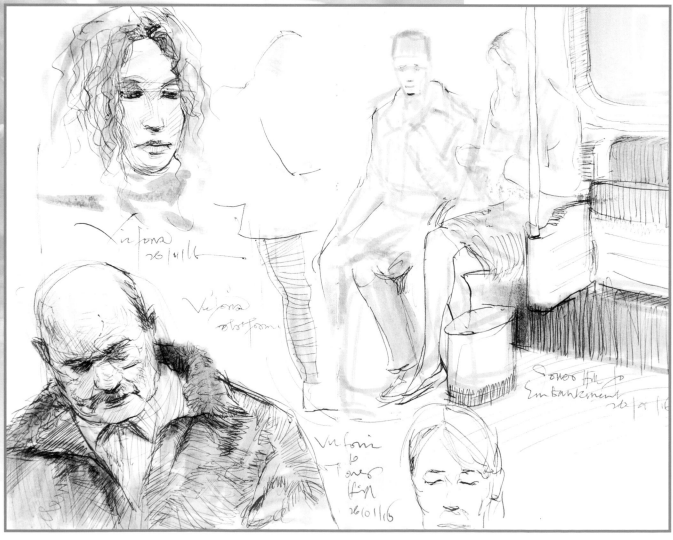

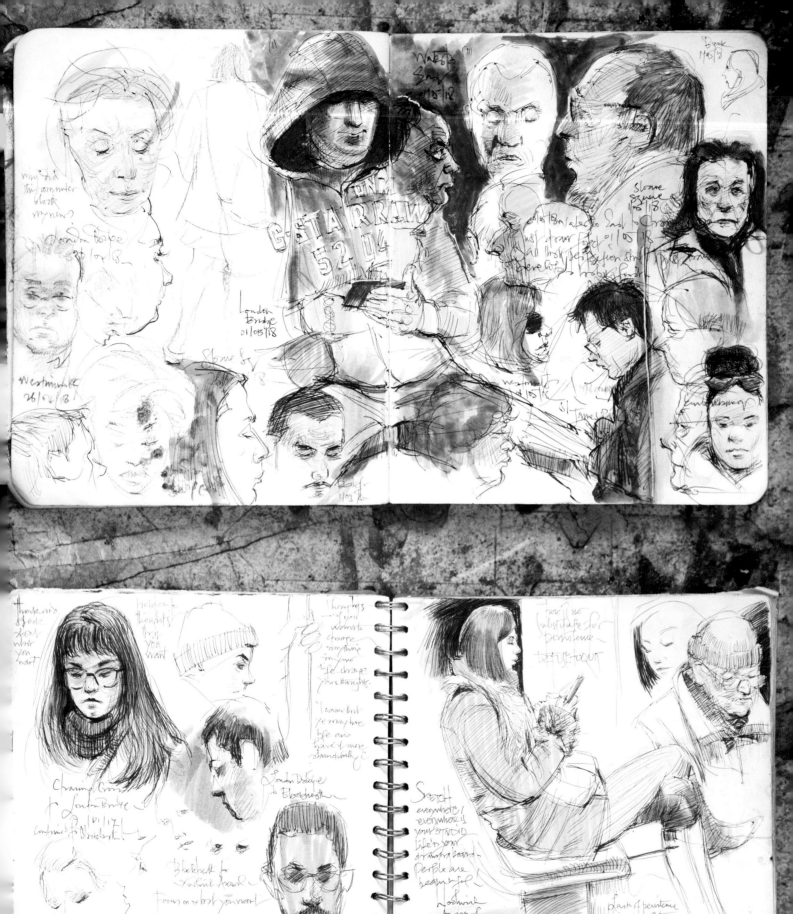

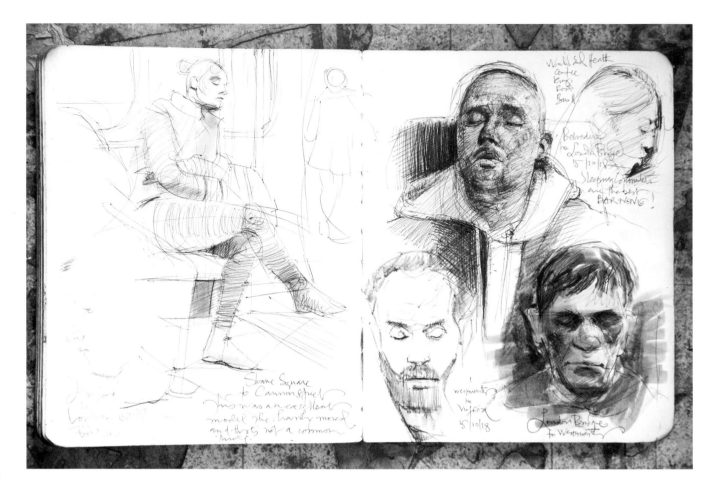

TIPS FOR SKETCHING IN PUBLIC TRANSPORT

- Make sure you have a compact sketchbook, no bigger than A4 – 210 x 297mm (8½ x 11¾in).

- Where you decide to sit in public transport matters a lot. Don't be in people's faces or directly opposite them; they may feel intimidated.

- Sketch with a smile on your face and if anyone asks why you sketch, politely explain the reasons for your passion.

- If you are a bit timid, sketch sleeping people or those really glued to their phones.

- Sketch lightly, focussing on the person you are sketching, not the paper. This helps you to resist sketching what you only think is there.

- Be ready to seize every opportunity to sketch on public transport. Hold your sketchbook in your hand or in a pocket, not squirrelled away in a bag. You must be able to quickly access it when you spot an interesting commuter.

- While sketching on the trains, if I get any bad looks or sense that danger is ahead, I'll follow my heart and stop immediately. If anyone tells you to stop, cooperate and stop.

- Don't go for perfection: go out to develop the habit to observe, analyse and respond.

- Have at least two drawing materials for this challenge: one drawing tool for lines and one for tones. It helps you work faster.

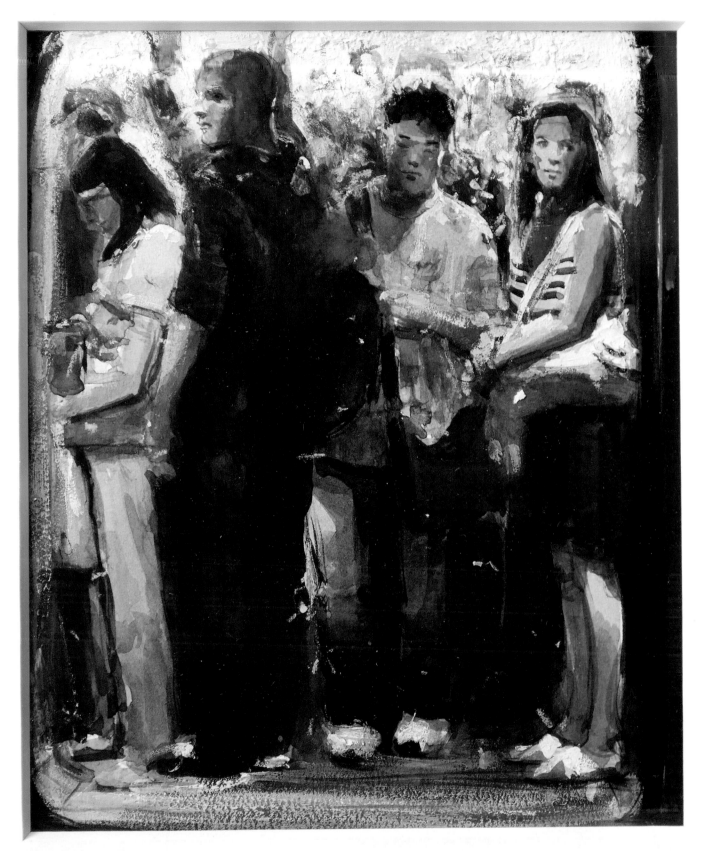

Internal Congestion

I painted this watercolour and coloured pencil piece from a quick sketch and photograph. The train stopped and there was a long delay before the doors closed. I liked the packed feeling of energy in there. I added some really random marks with my brush by holding it at the end and tapping it to the surface. This is a great way to capture the effect of movement and energy.

Pub scene

This project is of Lots Road Pub. It's a wonderful place to eat but also to sketch. The whole reason why I wanted to sketch this scene was to capture the interior of a place I know well. Whenever I visit the place without my sketching materials I feel as if I'm missing out, because the light is just amazing. On this occasion, towards the late evening it took on a particularly beautiful ambience.

This project shows how I go about sketching interior surroundings with a few people in it. It shows how I can make the best use of page spread to capture the scene from my position. I always look for a good vantage spot from which I can get a sense of space and reality.

Sketching scenes like this will help you gain useful experience in capturing a three-dimensional space on a two-dimensional surface. It can seem tricky, but once you are able to develop a clear vision of what exactly you plan to achieve with the sketch, you'll know what to focus on.

We use the contour technique to get the basic furniture in position and also angles to get the flow and position of the tables. Once the shapes are in place, we switch to dual wash pens of various browns and greys for tones. They help create depth in this lovely pub. It's so important to get the tones right as this is what gives the scene richness and depth.

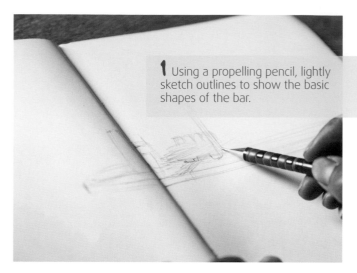

1 Using a propelling pencil, lightly sketch outlines to show the basic shapes of the bar.

You will need

Stillman & Birn premium soft cover sketchbook, 203 x 254mm (8 x 10in)

Ballpoint pens: brown, black and white

Propelling pencil

Tombow dual wash pens: sand (992), tan (942), cool grey 1 (N75), cool grey 5 (N65), and warm grey 1 (N89)

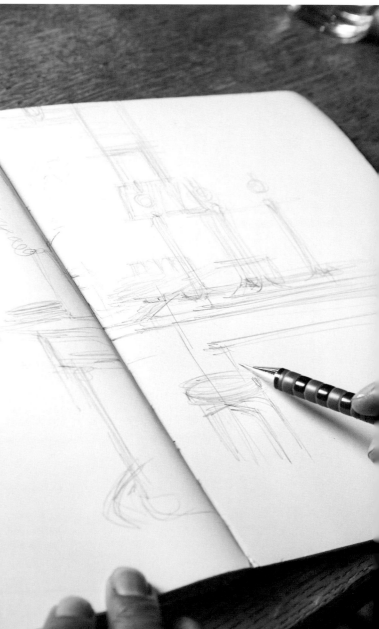

2 Use the shapes of the bar to help with placement of other objects. The top of the bar will help to establish the stool in front of the bar, for example.

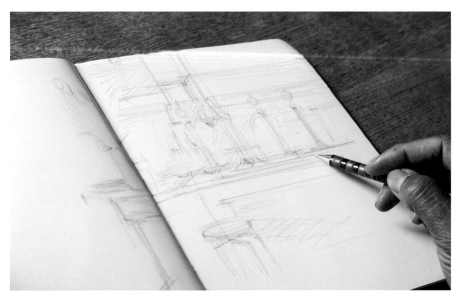

3 Don't overwork the bar. Feel your way around with the pencil, rather than being over-precise.

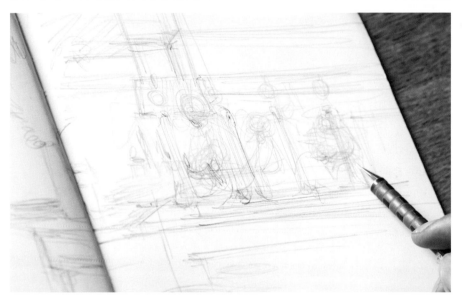

4 Change to organic lines to suggest the bar staff. These loose shapes position the people without pinning you down to a final pose, and contrast with the more definite lines of the building.

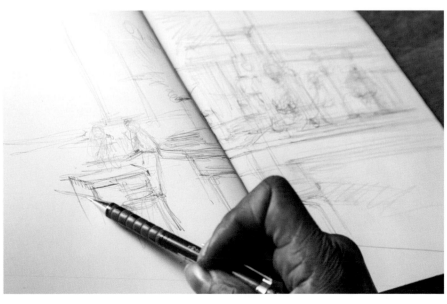

5 Using the bar placement to help guide you, start to rough in the dining area, including the diners.

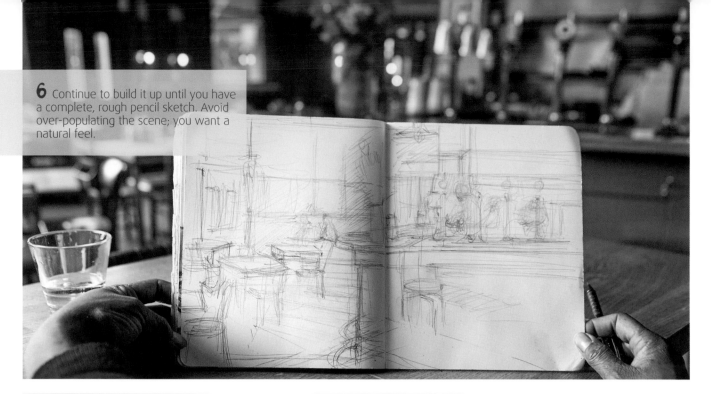

6 Continue to build it up until you have a complete, rough pencil sketch. Avoid over-populating the scene; you want a natural feel.

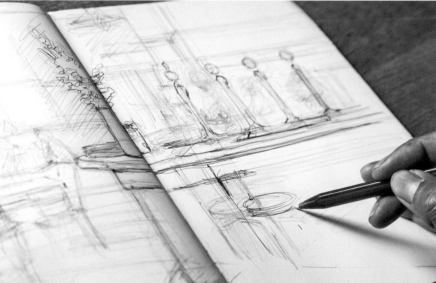

7 Change to a brown ballpoint pen and draw a contour line outline to tighten up the drawing. As before, start with the bar.

8 As you continue the contour line, don't stick rigidly to your pencil lines – after all, you may have made a mistake! Keep looking at the scene in front of you to confirm the line is correct before finalizing it with ballpoint. If a figure stands still in a pose you like, break off and sketch them in.

9 Once you have contoured the bar area, move on to loosely contour the dining area. Work more loosely and rapidly, using the existing pencil lines to give you confidence.

10 Again, build up contour lines, joining the different objects and figures by flowing from one to the next. You want to create a sense of closeness and connection between the people in the pub.

For a complex scene like this, don't be afraid to correct and re-draw. Work carefully, with lots of reference to what's in front of you.

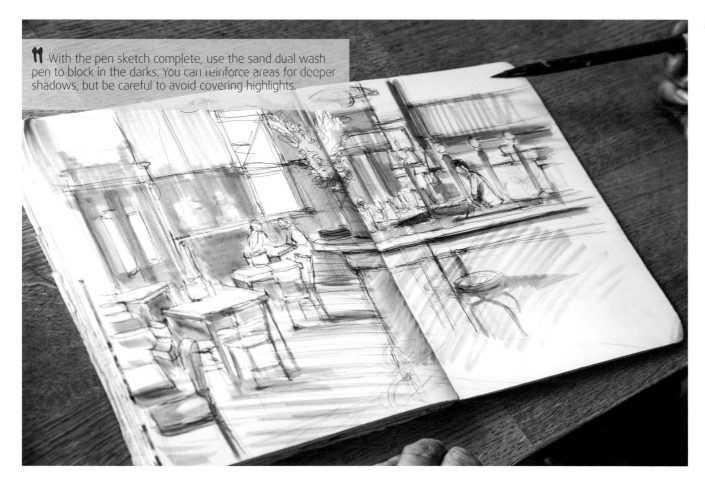

11 With the pen sketch complete, use the sand dual wash pen to block in the darks. You can reinforce areas for deeper shadows, but be careful to avoid covering highlights.

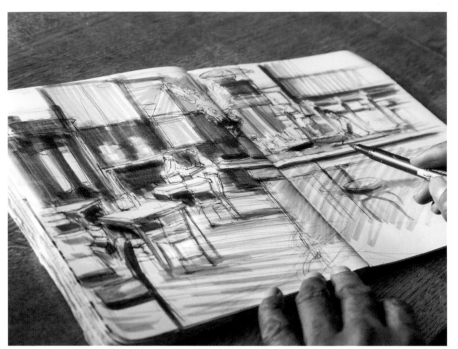

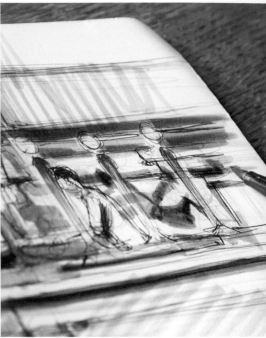

12 Once the shadows are in place, change to the cool grey 5 dual wash marker and strengthen the deepest darks using the side of the marker.

13 Hint at some of the figures behind the bar with light touches of the same brush marker.

14 Change to the cool grey 1 marker for cooler midtones.

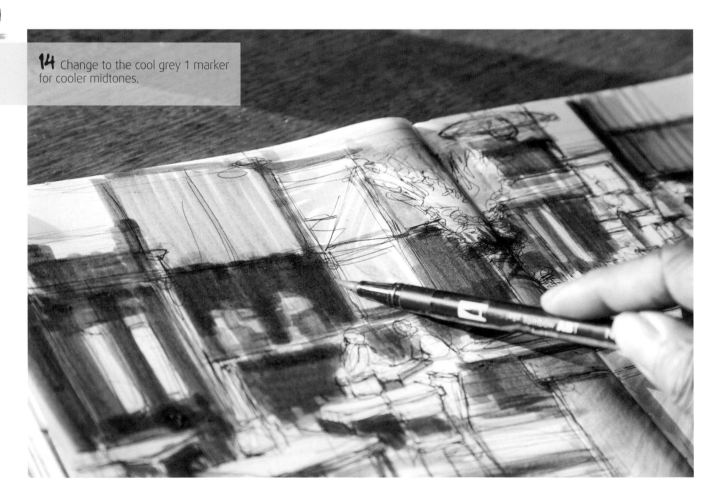

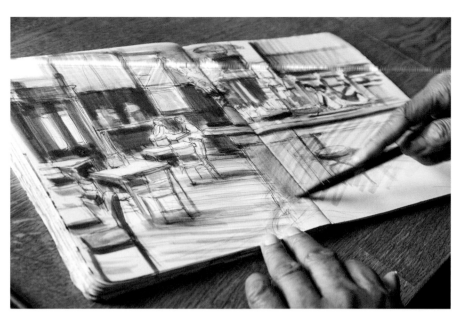

15 Vary the midtones with the warm grey 1 and tan markers.

Avoid the pressure of precision – as a sketch, you want an impression; aim to get the right feel of the setting, not a photograph.

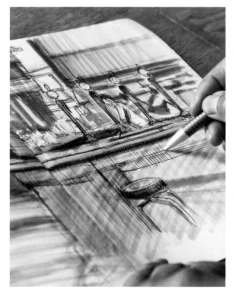

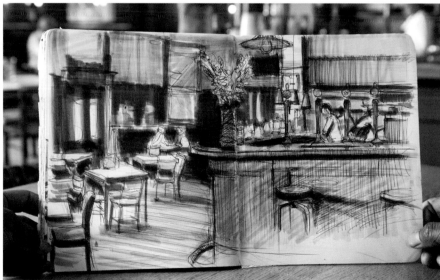

16 Change to a black ballpoint to re-establish and develop the detail in the foreground.

17 Continue building up the line work. This added detail creates contrast between the more developed bar area, and the simpler background of the dining area. This gives the foreground weight, creating a sense of distance and depth to the whole sketch.

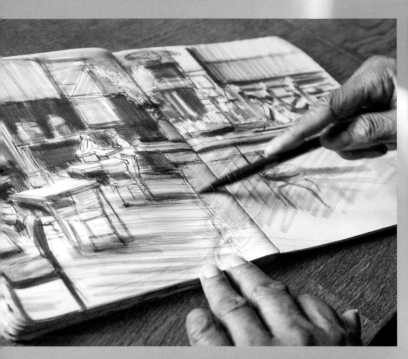

18 Make any adjustments to the tone using the dual wash markers.

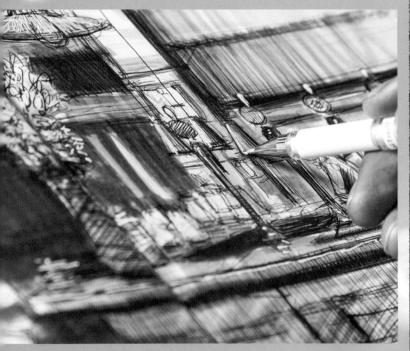

19 Use the white ballpoint pen to touch in any bright highlights, particularly on the metallic surfaces.

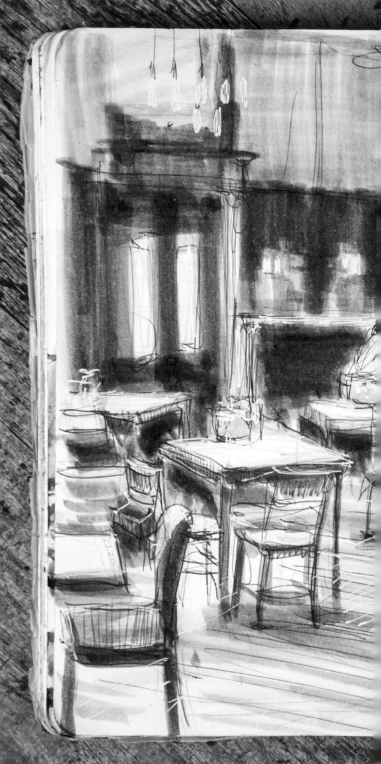

The finished sketch.

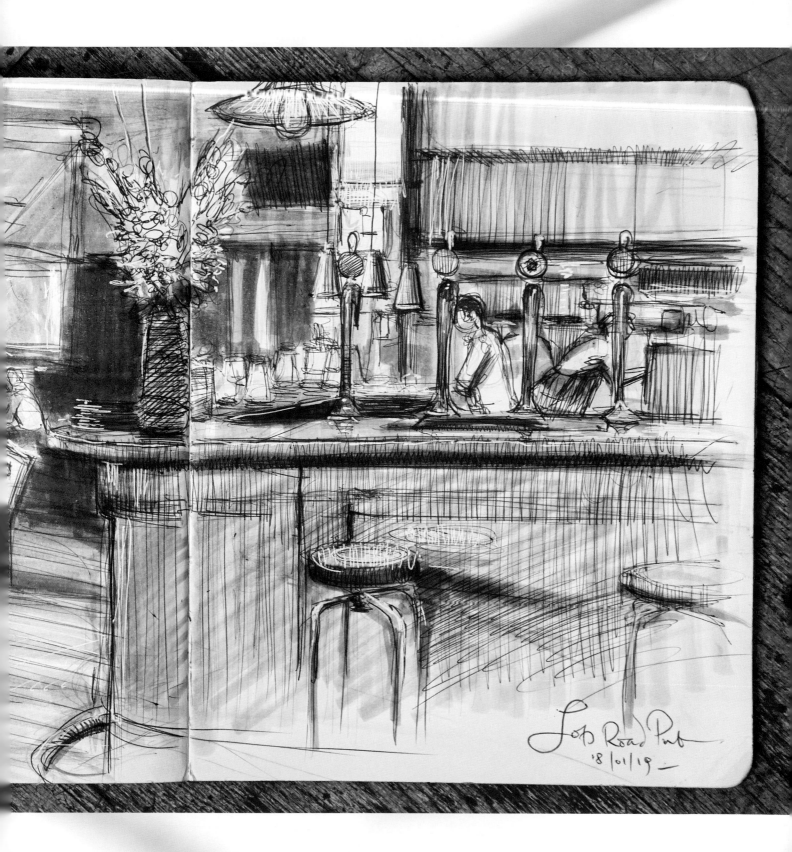

Lots Road Pub
18/01/19

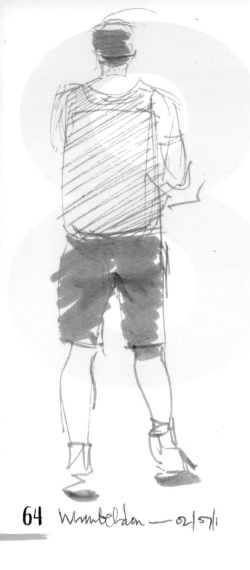

PEOPLE OUTDOORS

The Addictive Sketcher is like a hunter, always looking for fresh prey. While out in the fresh air, the eyes of the sketcher are never at rest. The passion never dies.

Whenever you find yourself at a bus stop, in a park, or along the street, you will find gatherings of people that are just crying out to be sketched. The same is true of more pre-planned events: crowds attending a concert or watching an open-air film, for example. It's time to bring out your sketchbook and sketching tools to capture them in the wonderful outdoors.

Always tell yourself that you are addicted, even if you feel you are not. It is the mind-set that matters. Really believe you can't go a day without sketching – that you might fall sick if you don't sketch. This is the way I treat myself, this is how I keep pushing myself. It sounds crazy but it's the truth! I am always saying, 'How about that?', 'Wouldn't that work out fine?'

64 Wimbledon — 02/07/1

This brown monochromatic sketch was made when I took my kids to the park. They were playing happily, so I kept one eye on them while sketching these two ladies chatting. I then filled in the rest of the page simply, giving a sense of the distant landscape.

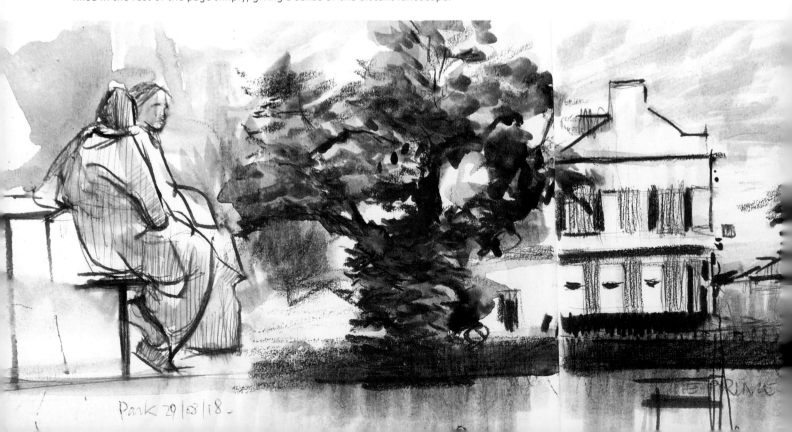

Park 29/08/18

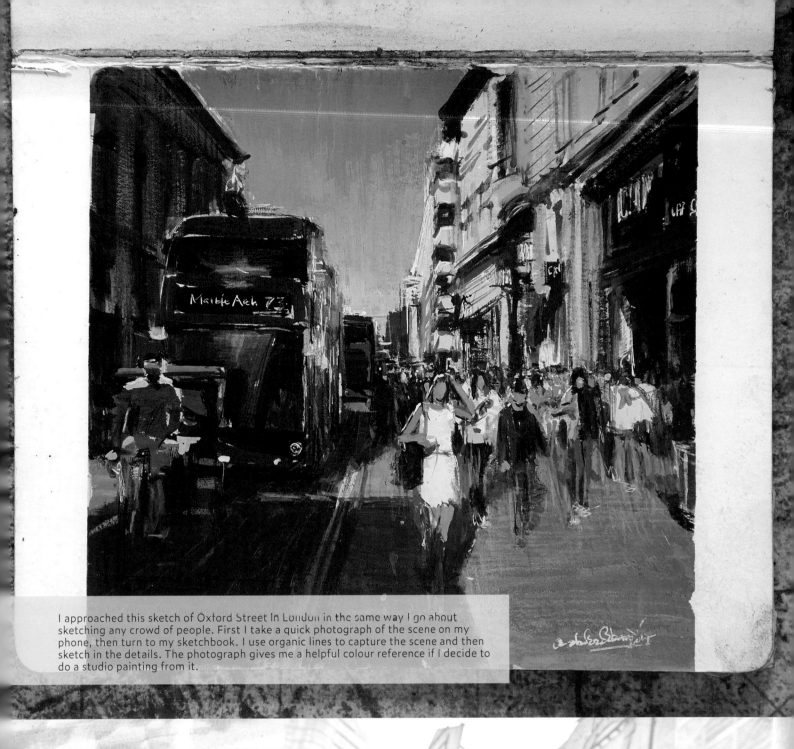

I approached this sketch of Oxford Street in London in the same way I go about sketching any crowd of people. First I take a quick photograph of the scene on my phone, then turn to my sketchbook. I use organic lines to capture the scene and then sketch in the details. The photograph gives me a helpful colour reference if I decide to do a studio painting from it.

The world is your studio. Never let anything remain unsketched.

On the streets

If you are fortunate to live or work around a busy street with people going and coming from their different places, nothing should stop you from sketching. You do not need to make finished sketches of the people passing by – just go all out to capture their gesture, their movement and body language.

If you are one of those *plein air* painters who would love to add figures to your scenes but never do because 'they don't come out right', this sort of sketching is where you will train yourself to be able to do just that from memory. It is also good training for the portrait painter, who would love to do compositions of figure studies or formal conversation pieces.

Most of these sketches were unfinished, but it's exactly because of this that they communicate the speed at which they were done and the sense of people moving, standing or sitting.

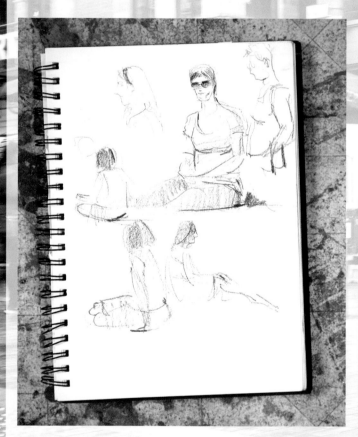

Above and opposite:
I use many sketches like these as reference for my paintings because the figures are great to add to incomplete paintings I have done outdoors.

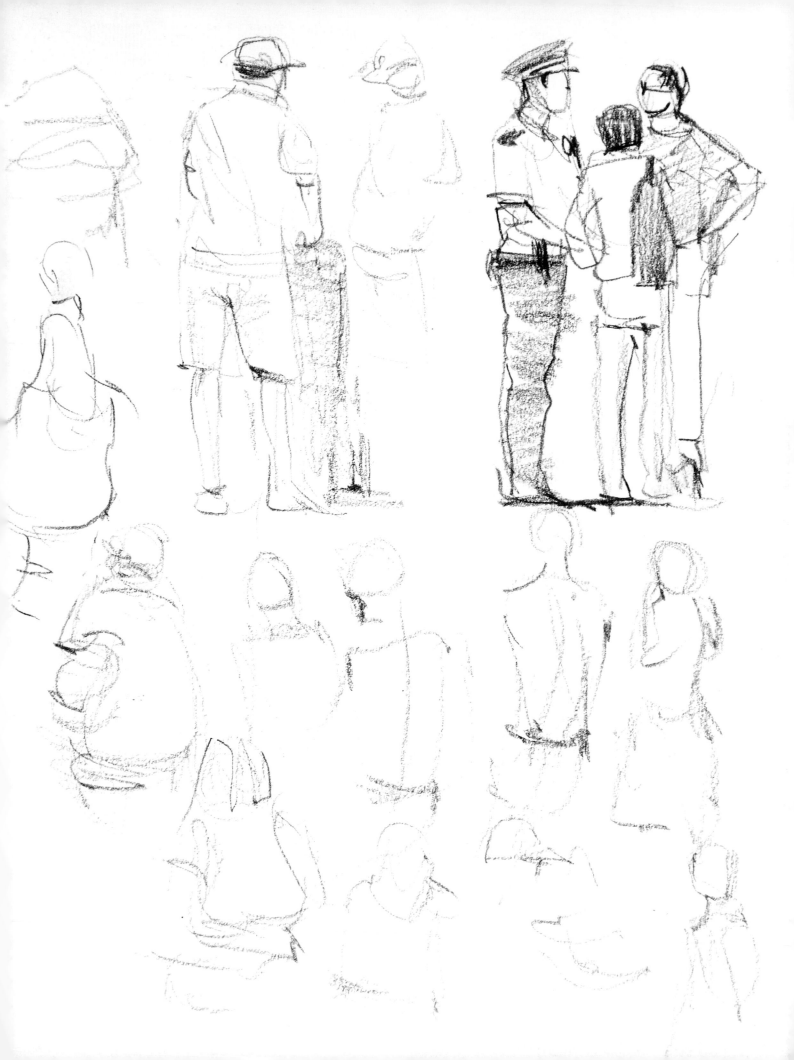

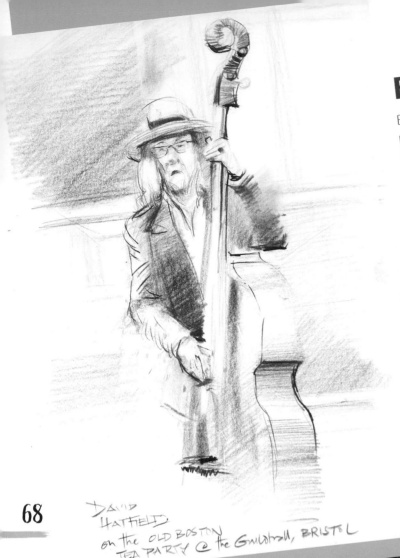

DAVID
HATFIELD
on the OLD BOSTON
TEA PARTY @ the Guildhall, BRISTOL

68

Buskers

Buskers are great to sketch because they attract crowds of people. While others are sitting or standing there recording them with their smartphones, you just need to pick a spot and start sketching.

I always start with very light rough, organic lines to get the overall feel of the person playing. Then I focus on the hand that is playing and, if I can get that, I'll build around it and keep the sketch alive.

Lest I forget – before starting to sketch buskers I let them know and see me put something into their collection hat. Nowadays many have card payment devices where you can just tap and it will credit their account with a payment. Once they have seen you do this, they will feel more relaxed and you can get on with your sketching. You might even attract more people who want to watch not only the musician but also the sketcher! It would then become some sort of combined musical and artistic performance.

Some street entertainers move a lot and some don't. I suggest that you start off with someone who isn't moving very much and who maintains almost the same position throughout the period they are playing, like the cellist in the sketch to the left.

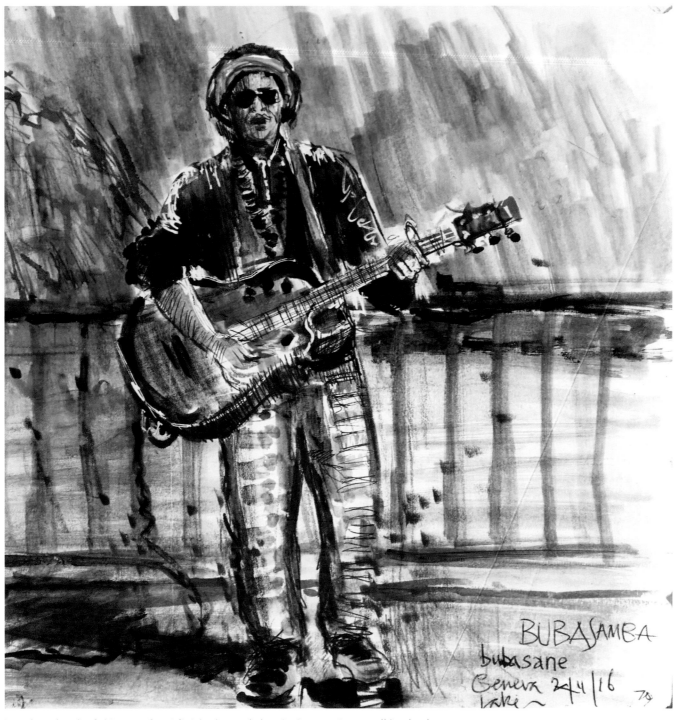

BUBASAMBA
bubasane
Geneva 24/4/16
Lake ~ 79

I made a sketch of this guy after I finished a workshop in Geneva. I was walking back to the hotel when I saw him. Following my usual procedure, I sat to sketch and we ended up singing and dancing together. We remain friends on social media even now.

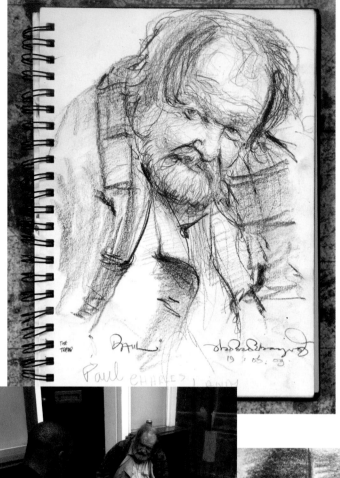

Homeless people

For many years I worked with the charity St Mungo's which, at the time, was the largest provider of housing for the homeless in the UK. My history with the homeless and vulnerably housed has helped me relate to them on a down-to-earth level and we are able to connect quite quickly. Once the barrier of communication is overcome and someone gets to trust you, the rest is history!

The thing that continually draws me back to sketching the homeless is that I love a face that has character. The face of most rough sleepers tells their story, and because of the constant exposure to different weather conditions, they often have rugged skin and sometimes longer hair, which all add to the power of the resulting sketch.

While chatting to someone, get to ask how they are feeling; show them your sketchbook and tell them about what you do. You may be surprised to find you are the first or only person who has taken the time to talk to them that day. If you are a portrait artist, you might be able to provide some modelling work for them if you can strike up a good relationship. Get them clothes, shoes, whatever will make their life easier and that has a way of changing their lives for the better.

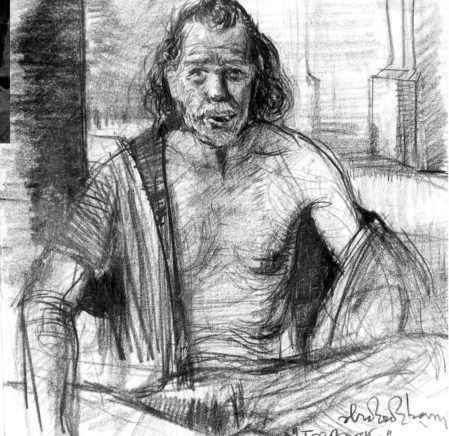

Give back: always be willing to support the people you sketch in one way or another. I think food is sometimes better than money because they may end up using that for things that won't help them in the long run.

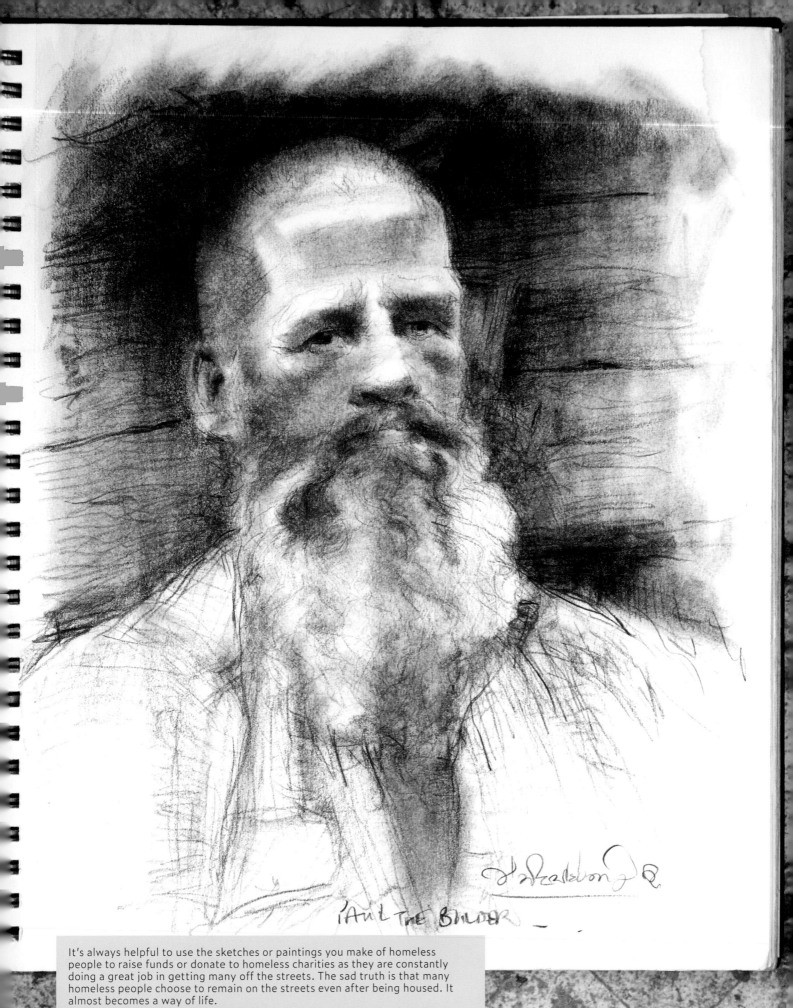

PAUL THE BUILDER

It's always helpful to use the sketches or paintings you make of homeless people to raise funds or donate to homeless charities as they are constantly doing a great job in getting many off the streets. The sad truth is that many homeless people choose to remain on the streets even after being housed. It almost becomes a way of life.

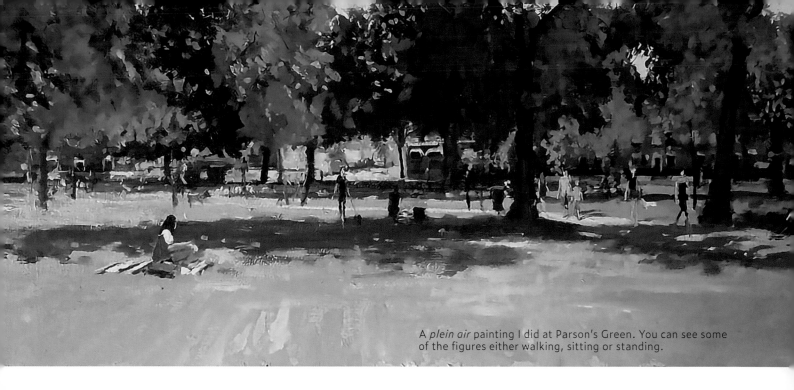

A *plein air* painting I did at Parson's Green. You can see some of the figures either walking, sitting or standing.

Parks and public spaces

In the summer, parks are a sketching feast, an explosion of people relaxing. Many parks have seating or deck chairs to use. You can get a deck chair yourself and just start sketching!

Target parks in the city – Green Park in London on a hot summer's day is a great example. People flock to these places in the summer and are so relaxed. They chill out or lie down, giving you lots of unusual poses to sketch. You just need to get in the thick of those places and seize the opportunity.

If you are a music lover or a sports lover, aim to arrive before the gig or game starts, and spend a little time sketching. Sports day or the end-of-year performance at your children's school is another good opportunity. Teachers and other parents might frown at taking photographs, but as long as you get permission beforehand, sketches are almost always received with delight!

It could also be that you've taken your child for football practice. While waiting at the touchline, bring out your sketchbook and record parts of the game. Once you begin to develop the habit of making the best of every opportunity you get to sketch, you'll be shocked at how much – and how quickly – you improve.

72

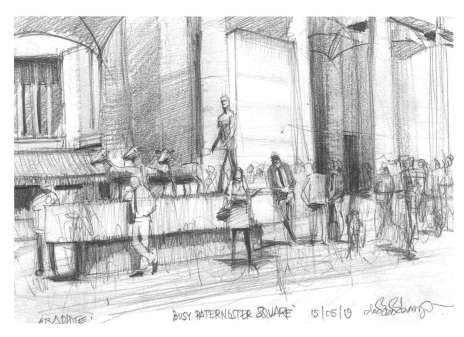

These people were sketched at Paternoster Square as I ran a workshop on sketching in public spaces. I used organic lines to capture the people standing and moving because one-line sketching does not work with lots of figures: you need lots of light lines to capture the movement. You can then darken the lines once you are sure that the movement has been captured accurately.

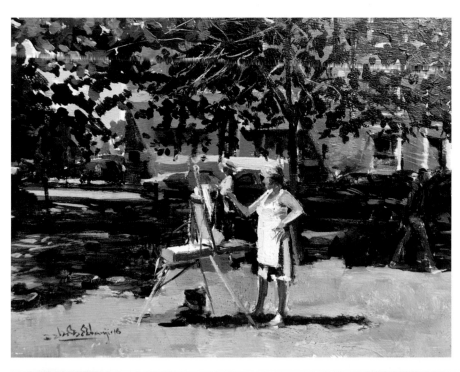

A study of Patricia painting during a Society of Fulham Artists & Potters *plein air* workshop I ran at Parson's Green; you can also see a dog walker in the background. This was captured with acrylic paint, which dries quite fast and is good for works like this so I can capture the spontaneity of the moment.

I was at Paddington Station, coming from Bath, when I saw these musicians playing. I quickly sneaked into the crowds that were watching and sketched. I also took some reference pictures which were used to paint this piece in the studio.

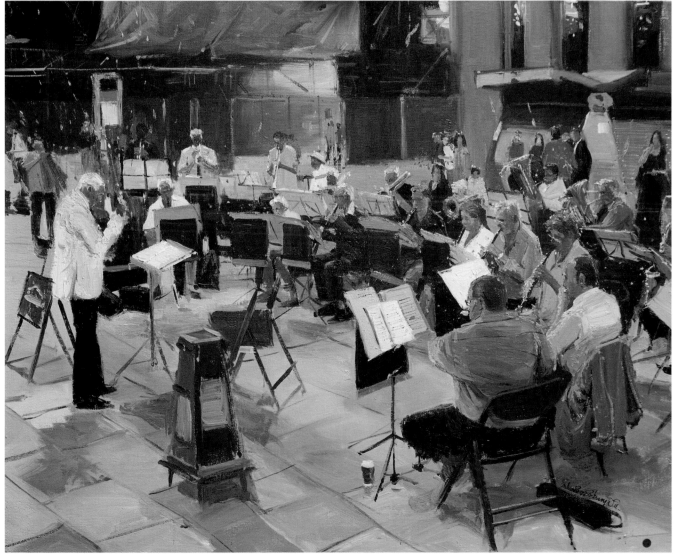

Sketching crowd scenes

By now you must have smelt all the facts in the air that I am seriously in love with sketching people. I love not only a few people but crowds of people – it's just an excuse to sketch or paint faces, which are my core passion. If I could sketch faces all day long, that would suffice! It would do! I just love them. So, when it comes to sketching crowded scenes, all I am really interested in is the individual faces of the people and their body language. I love people-watching!

This is my formula: I first use organic lines to quickly capture all the contours of the people and their main gestures or body language. I do this broadly, then go back in and get some detail. This organic sketch gives me a very lively feel of the scene, which a photograph cannot capture.

Photographs do have their place. If I was planning a studio painting like the watercolour shown opposite, I would use photographic references to build up more individuality in the faces.

When you see a crowd of people, practise using organic lines to capture the movement and body language of all those present. Use circles for the heads and keep it in one tone. This helps to give an overall dominant effect to the whole sketch. I did a series of studio paintings around the theme of 'Rush Hour' this way and the procedure was always the same:

1 Take a reference picture.

2 Sketch broadly with organic lines.

3 Sketch in the details.

74

This is the study sketch for *The Bus Stop, Earls Court*, opposite. I used dual wash markers: Zig Art & Graphic Twin Pens to sketch the figures with the brush tip, then swapped to brown Tombow markers to block in the tones.

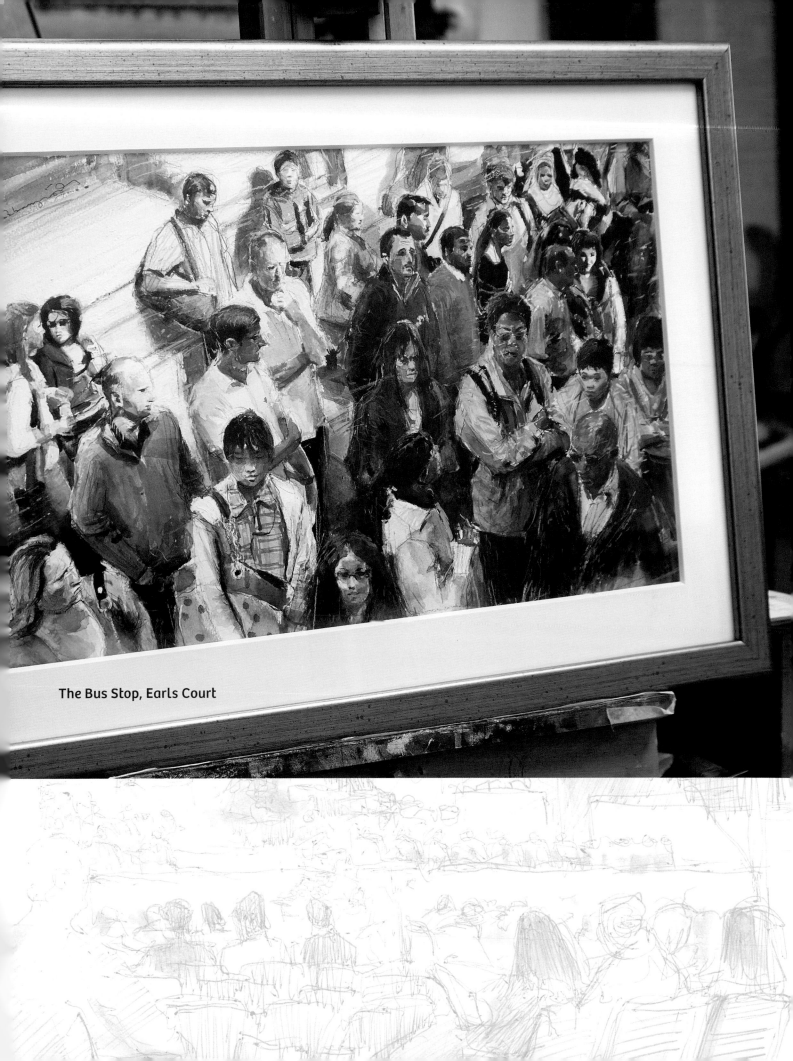

The Bus Stop, Earls Court

Busker

This is a profound view of a busker in London. She played brilliantly on the cello and it was a treat to listen and to sketch her at the same time. It was January: really cold, but I was all padded up and ready. I noticed she also had these fingerless gloves on to help combat the cold. I love classical music and to be able to see someone playing a more unusual instrument in the streets without having to go into a concert hall was a double treat!

Rather than using your camera or phone to snap something or someone that you find interesting, it's great to sketch. Making this sketch was also an opportunity for me to catch a scene of something a bit different, with an eye towards producing a later painting.

In following the steps I used to produce my sketch, I want you to see how it is possible to do a full drawing of someone who keeps moving one part of their body while playing; and also to capture the sense of the environment around her for a clearer understanding of where she was on the day.

Such scenes currently make up part of day-to-day life in the heart of London and this says so much about the city I live in and love. It is our great responsibility to record these genre scenes in sketches for oncoming generations to see. Who knows? Perhaps a few years down the line such scenes may have become a thing of the past; people will look at the sketch and wonder what it's all about. But it should not just be photographers documenting such sights. Artists should share with the world the life of the people in the times they lived.

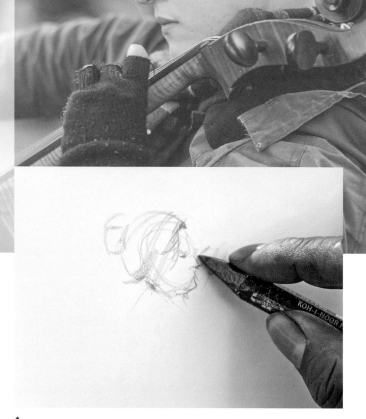

1 Starting with the head, begin sketching in the shape with the 4B graphite stick. Use organic marks to capture the line of the hat and features.

You will need

Stillman & Birn premium soft cover sketchbook, 203 x 254mm (8 x 10in)
Koh-I-Noor chunky graphite sticks: 4B and 6B
Staedlter graphite pencils: 2B, 4B and 6B
Eraser

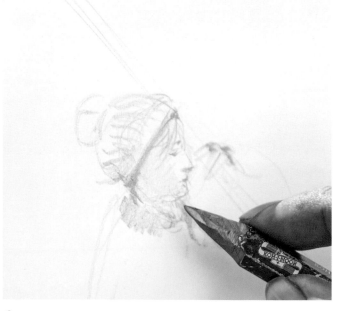

2 Add the hand and the line of the cello's neck, then use the side of the pencil to achieve a softer look for the scarf.

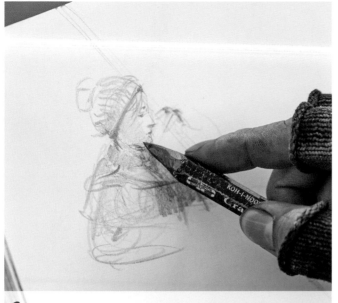

3 Use searching, circular marks to build up tone in the shoulder and right arm, working gradually downwards. The arm is moving continually, so build up lots of partial marks with organic lines – you can establish the final position later.

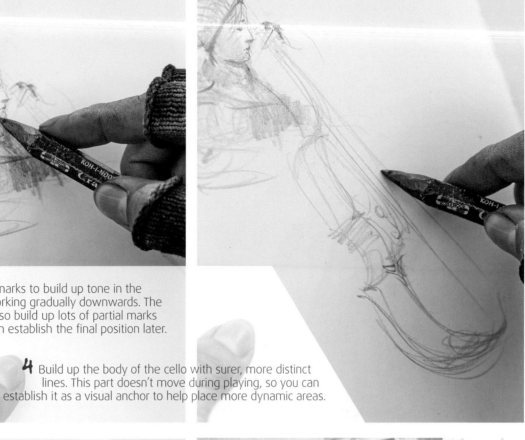

4 Build up the body of the cello with surer, more distinct lines. This part doesn't move during playing, so you can establish it as a visual anchor to help place more dynamic areas.

5 Still using the 4B pencil, continue to develop the rest of the musician's body, building up tone as you work. Use more angular marks and treat the background as an extension of the figure. Adjust the cello as you work, if necessary.

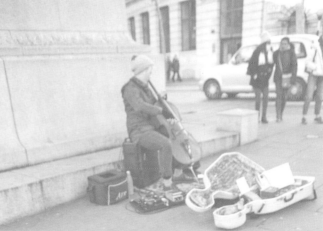

It's fine to get a doubled-up or overlaid shape in a sketch: it's more important to get it right than neat.

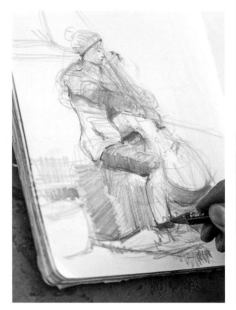

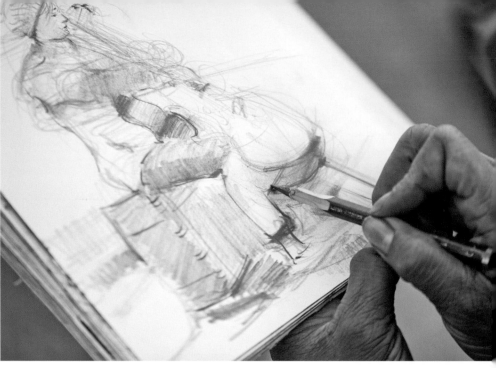

6 Build up tone in the base of the cello and in the deep shadows with the 6B graphite stick.

7 Develop structure in the seat/speaker case, then swap to the 4B pencil to strengthen the tone in the cello with hatching – parallel lines. Use this to describe the texture and wood grain of the cello itself.

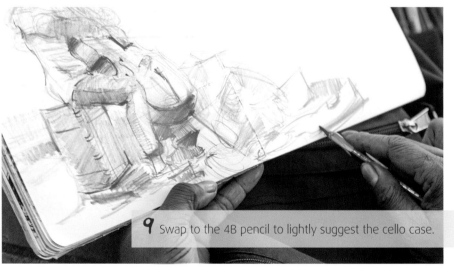

9 Swap to the 4B pencil to lightly suggest the cello case.

8 Add texture to the musician's coat and strengthen the depth of tone with the 6B pencil.

10 Still using the 4B pencil, continue to develop the tone in this area, balancing it against the busker herself. Be careful not to draw the eye away from her by creating too much contrast in this area.

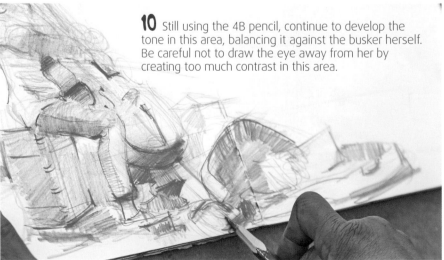

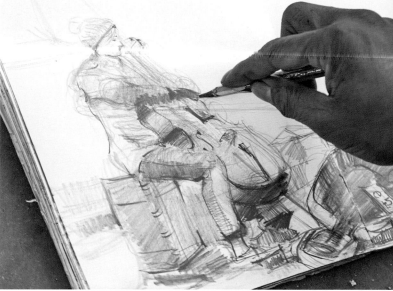

11 Continue building up the case in the foreground. The shape is complex, so keep looking at the subject in front of you; and don't be afraid to alter the lines or tone with the eraser.

12 Return to the figure and give the right arm more definition. Don't fix it in place completely – you don't want to lose all sense of movement.

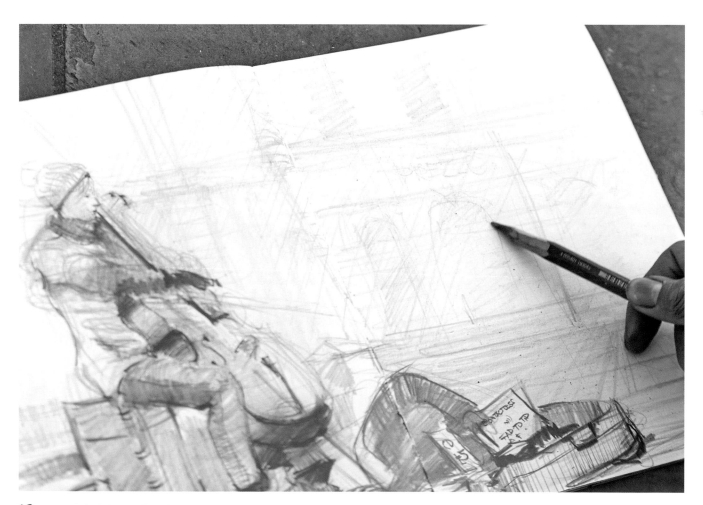

13 Use the side of the 4B pencil to add very light lines, just to hint at the seating. Add some very light hatching to the background shadow, to give the sunlight some contrast.

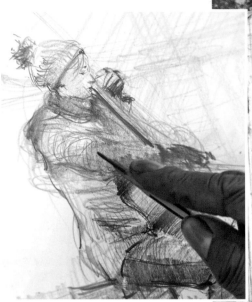

14 Add finishing touches to the musician with a very fine HB pencil. For the pom-pom on her hat, tap the surface quickly and repeatedly with the side of the pencil lead.

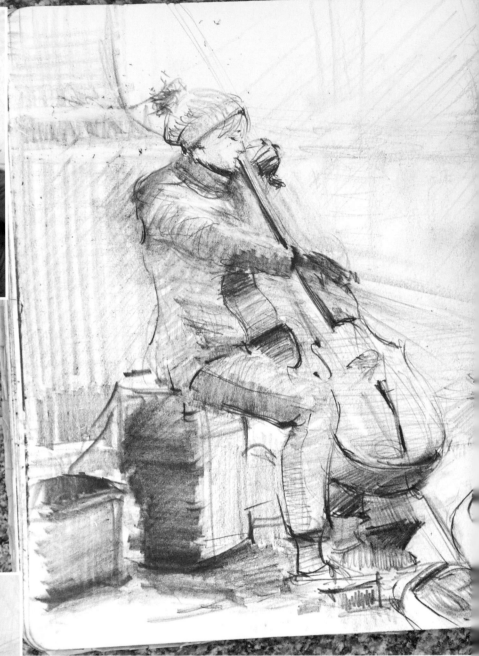

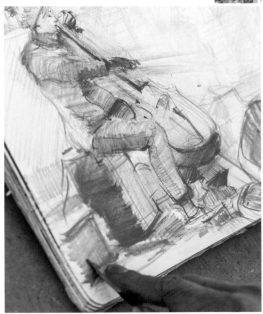

15 Develop the shadows with the side of the 4B to enrich the deep tones; then use less pressure for the midtones on the base of the pedestal.

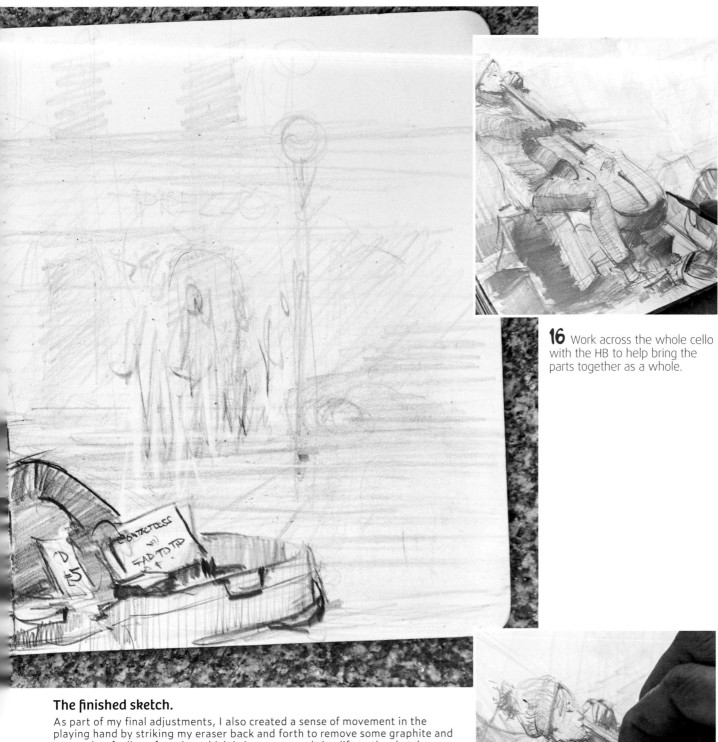

16 Work across the whole cello with the HB to help bring the parts together as a whole.

The finished sketch.

As part of my final adjustments, I also created a sense of movement in the playing hand by striking my eraser back and forth to remove some graphite and create that feeling of motion which is important to bring life to the sketch.

17 Use an eraser to lift out soft highlights, then make any final adjustments to finish.

PLACES OUTDOORS

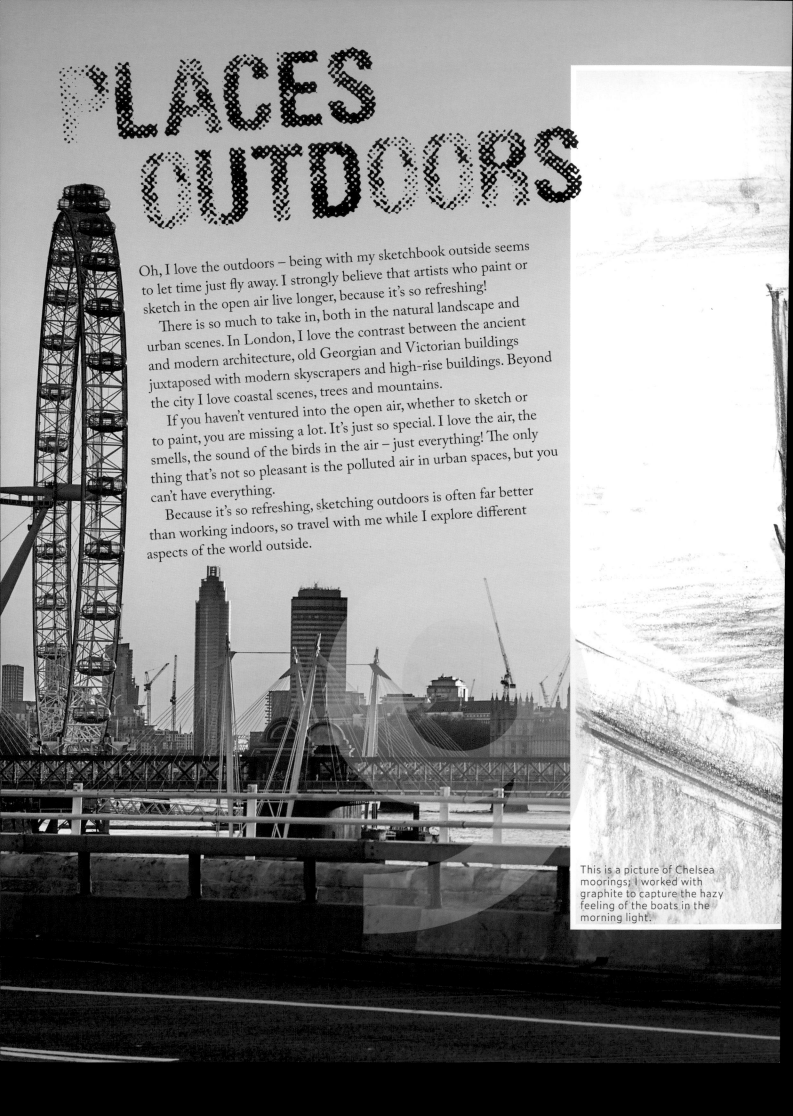

Oh, I love the outdoors – being with my sketchbook outside seems to let time just fly away. I strongly believe that artists who paint or sketch in the open air live longer, because it's so refreshing!

There is so much to take in, both in the natural landscape and urban scenes. In London, I love the contrast between the ancient and modern architecture, old Georgian and Victorian buildings juxtaposed with modern skyscrapers and high-rise buildings. Beyond the city I love coastal scenes, trees and mountains.

If you haven't ventured into the open air, whether to sketch or to paint, you are missing a lot. It's just so special. I love the air, the smells, the sound of the birds in the air – just everything! The only thing that's not so pleasant is the polluted air in urban spaces, but you can't have everything.

Because it's so refreshing, sketching outdoors is often far better than working indoors, so travel with me while I explore different aspects of the world outside.

This is a picture of Chelsea moorings; I worked with graphite to capture the hazy feeling of the boats in the morning light.

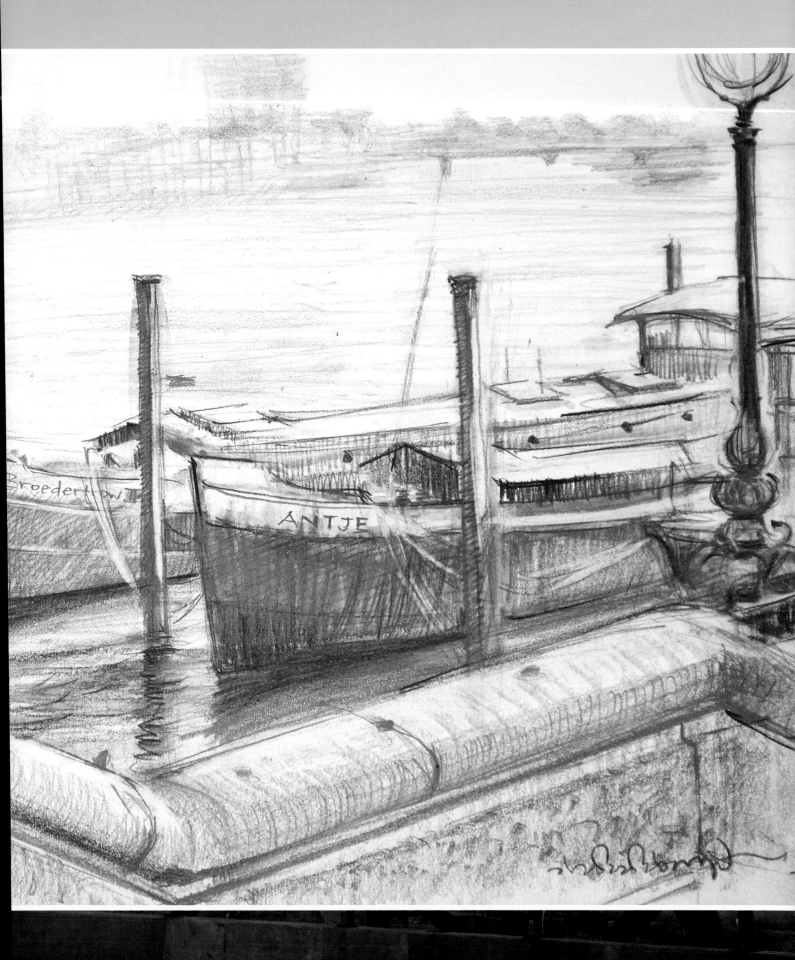

Simple landscapes

The most beautiful natural landscapes are often amongst the simplest. I love to work on such scenes with simple graphite and oil-based pencils, as can be seen on these pages. My main goal is to capture the drawing as accurately as I can, but I also aim to produce a picture of good tonal power. That way, if I decide to do a painting from any of the sketches, it is easy to do so.

When using the pencil in my landscapes I see the tip of the pencil as a brush, and I use it almost side-on to the paper to produce flat strokes. These marks are great for quickly and effectively capturing the sweeping mass of mountains of the foliage of a mass of trees.

Before starting this sketch, I used sandpaper to roughen the paper in a Stillman & Birn sketchbook – the paper in these is very heavy and can take a battering. I made sure it was really coarse then smudged powdered graphite into the surface with tissue to get an overall dark and middle tone. This is a version of the ghosting technique (see page 30) that uses dry charcoal dust, rather than mixing it with water beforehand. After the tones were settled, I began drawing in oil-based pencil and graphite. The final phase involved me taking out highlights with an electric eraser to complete the dramatic landscape.

This whole sketch, of Ilfracombe in the morning light, was done with my most trusted medium, graphite. I used very dark 6B and 8B sticks for the major shapes, sketching them in with broad strokes. I then drew in lines to get more details, before using an electric eraser to create highlights by removing some of the graphite.

This was sketched down rice mill way in Abakaliki. This sketch is so nostalgic because it reminds me of the great times I spent walking down this road just loving the trees, dusty roads, and the people walking back and forth, selling their goods or walking to the market. I sat on the side of the road and sketched in graphite; I used various strengths of line to depict the overall drawing and then I used broad strokes for the foliage.

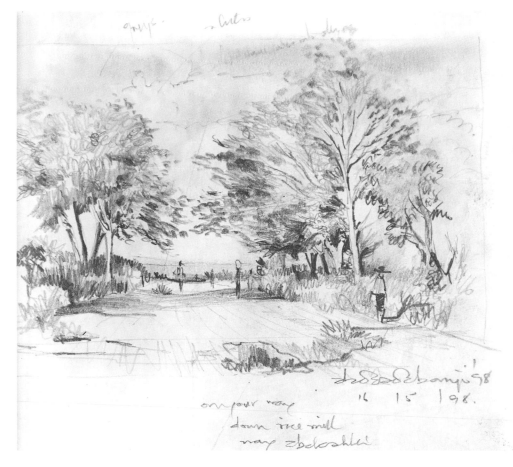

The urban landscape

I've painted more urban landscapes than any other theme in all my work. I just love the variety! Perhaps it's the architect in me. The urban landscape is as varied and enchanting as music: there are myriad tones and colours, there is harmony, and there are sudden warms and cools. There are verticals and horizontals and it just buzzes with life! For me, nothing beats the urban landscape, it's a place where you have the organic and inorganic in an amazing fusion. Because I live in an urban space and my studio is in the heart of London, walking and commuting and living in the urban landscape have influenced my work greatly. I don't ever think I will ever get tired of it, or run out of material to work on.

STREETS AND ROADS

If you live in the city, the most convenient place to really start to appreciate the urban landscape is probably your own street or road. Sometimes people can become so familiar with their own surroundings that they think such a subject is boring – but it usually only takes someone who is curious and a bit alien to the area to bring that very place to life. I remember the artist Ken Howard relating how he was once painting a bridge when a local man came up to him, looked at his painting and said, 'I have never seen this place looking so beautiful!'

The key to making the best out of an otherwise mundane place is to view it under different light conditions than usual. In compositional terms, make sure the shapes are unevenly distributed to add dynamism. Another approach is to focus on a particular area and make sure your sketch has a strong, clear focal point.

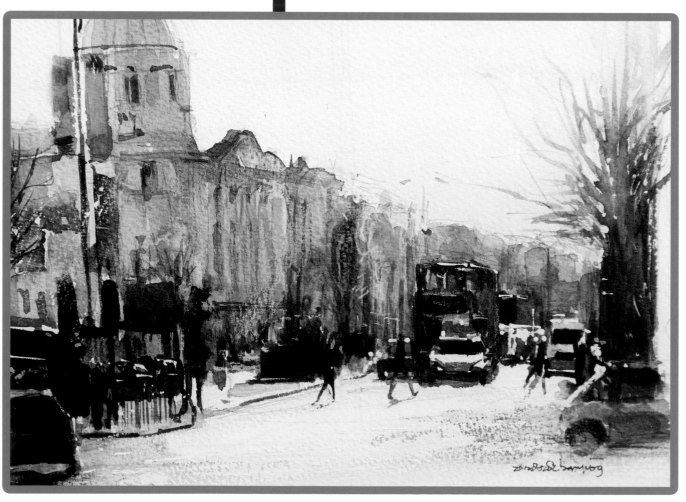

This was sketched with watercolour at Notting Hill Gate. You might think this sketch is a snow scene at first glance, but in fact it shows a very sunny day. The brightness is down to blazing sunlight reflecting from the road and the oncoming vehicles.

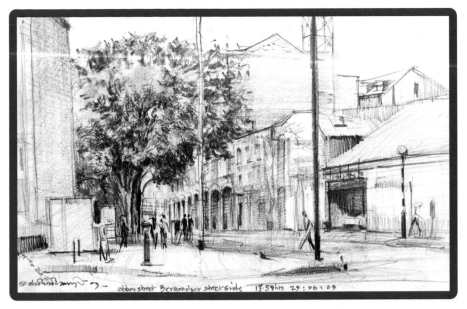

I did this sketch of Abbey Street in Bermondsey with graphite while sitting on a discarded bag of cement. I was drawn to sketch this scene because of the contrast between the organic shape of the tree and the more organized shapes of the buildings. I just love the contrast between organic and inorganic shapes.

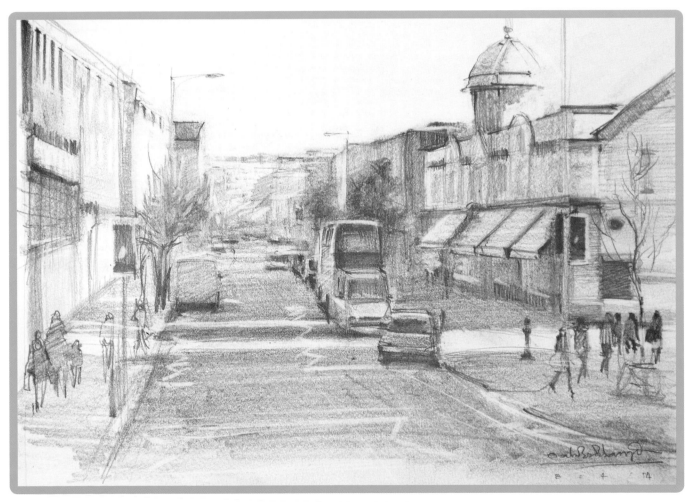

King's Road in Chelsea. To capture this vehicle-lined street from above, I used graphite with a softer approach. By this I mean I used a stump to smudge the pencil marks into a smooth, almost wash-like effect.

BUILDINGS AND PUBLIC SPACES

Some buildings have significance - monuments, sports stadia and other edifices of historical or cultural importance are good examples. Whenever you travel to a certain place, it's always good to ask the locals for any nearby buildings of great importance so that you can go and sketch them.

However, you should not forget the more personal importance people give to certain otherwise unremarkable buildings. I have observed that many people who buy my work are really interested in remembering particular buildings in particular cities where they have lived or worked for a period. They often like to have something of that city to take back after their working life is over, or they move on. Such scenes are usually lucrative.

On a more personal note, most of the places in the illustrations here also remind me of periods when I either worked in a place or travelled to that place.

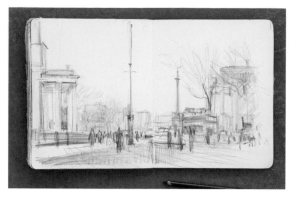

Looking at London from Charing Cross Road, you have St Martin-in-the-Fields on the left, Nelson's Column off-centre and the National Gallery to the right. I did this very fluid sketch using a blue coloured pencil. The organic lines show an example of the looser approach I take to sketching when I am simply trying to capture the essence of the place.

I love this particular building. The Royal Crescent in Bath is a dream for a lover of architecture like me. I spent almost three hours sitting on the grass in front of this majestic building to create what I call a more detailed sketch of the building. I worked in graphite, my true love when it comes to sketching.

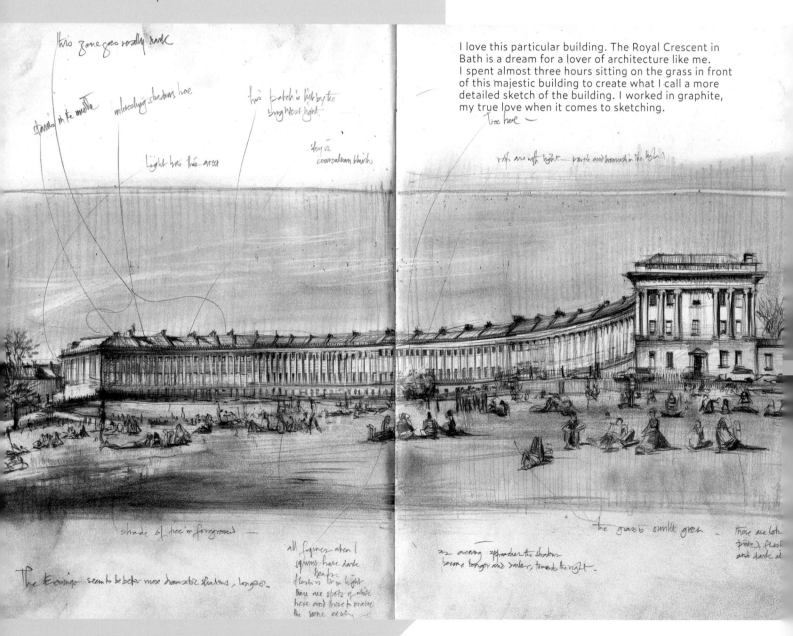

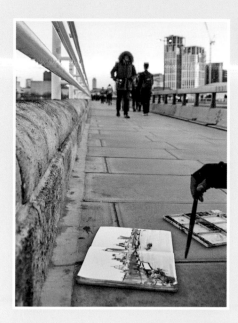

Using a brush pen is the most rapid approach to capture the London skyline from Waterloo Bridge. It was bitterly cold, and sunset was approaching, so there was no time for measuring or checking proportions. In situations like these the main thing to aim for is to capture the different shapes of the buildings, allowing them to run into each other to create flow and a unified effect.

To create this effect, I pre-prepared this paper with gesso, put a wash of yellow ochre over it and then used an oil-based pencil to sketch. I also mixed graphite dust with water to add some light cloud effects in the sky.

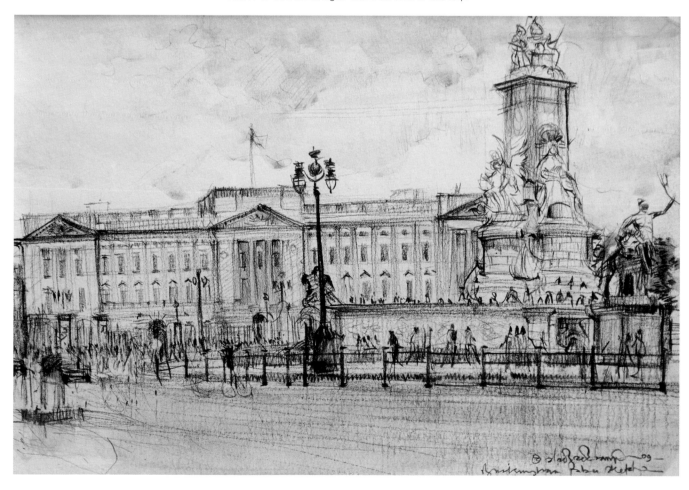

Street furniture

Cars, streetlamps and statues all make great things to sketch. I love statues in particular because they offer another way to sketch people and improve my figure drawing. In fact, these are sometimes better than living people, as statues don't move. As a result, the studies can really become great pieces. It's just like training to draw portraits or figures from plaster casts.

I had just arrived in the city of Geneva and was wandering around enjoying the fresh air when I stumbled on this lovely statue of Jacques Rousseau. I love this particular scene because of the airy feeling around it and the opportunity to put in a few nearby trees. I used brown coloured pencils and a brown ballpoint pen.

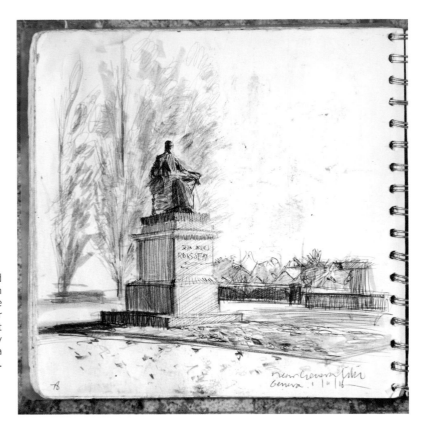

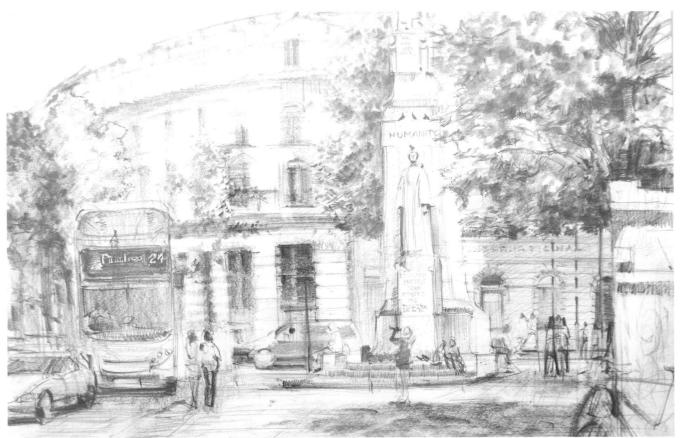

I really love this statue of Edith Cavell in St Martin's Place. Edith is rooted and propped up against a large long monument and it just looks glorious! I could not only take on the statue but had to add the surroundings too. Capturing cars is a great way to improve your perspective skills, as they are generally the shape of a box. The key thing is finding a way to simplify them.

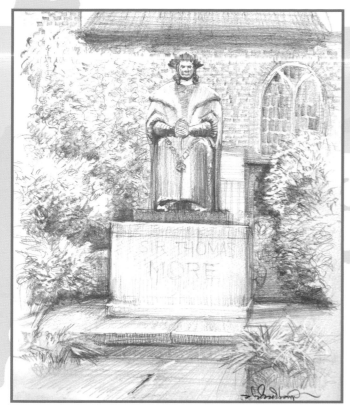

Sir Thomas More statue, Cheyne Walk. I spent about two hours on this sketch, making sure I got to a refined level of detail. I think I was drawn by the level of detail on the statue – but to be realistic, I also happened to have an unusual amount of time on my hands when I chose to sketch this!

Sparkling Water, Sloane Square

This was a *plein air* painting of the statue at Sloane Square. I worked in oils and I was out to capture the movement and spontaneous effect of the splashing of water.

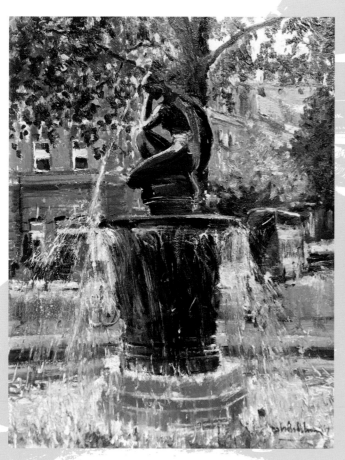

The Diana Statue, Green Park

I painted this in oils on a panel when conducting a *plein air* workshop one summer's day at Green Park. I loved the dynamic gesture of this particular statue; it was simply inviting to be painted. Beauties like this surround us everyday but most people do not see them. It is one of our roles as artists to show the beauty around us.

Trees

If people are my first love, trees are second! I see them as living monsters. They break up the unified sky space in a landscape and add powerful compositional elements that help in balancing all the parts in a painting.

I can't count the number of times I have used trees in my urban landscapes to show scale, hide detail, create a centre of interest, to direct the eye of the viewer through shadows, or to show the effect of light on a particular place.

I am always looking our for scenes with trees because they help to break up a picture that might otherwise be over-saturated with straight lines and linear perspective. They make it easier to paint urban scenes by taking a lot away from the complexity of buildings and other structures.

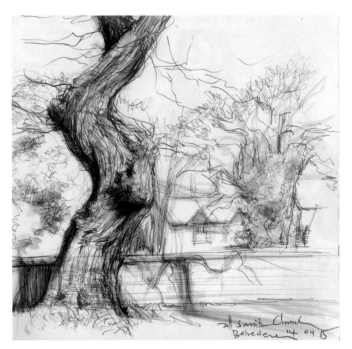

At Upper Belvedere in Kent, there is a lovely All Saints' church with a grand old tree. This is the trunk of the tree. I sat right nearby and captured it with graphite in my sketchbook. I love tree trunks because they give me room to explore textures and shading with lines of various weight and thickness.

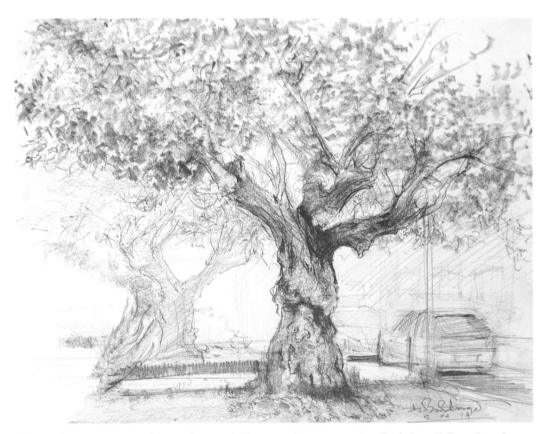

These twin trees are very short and stunted. They caught my eye as I walked along Fulham Broadway into King's Road. They were almost identical, so I honed in on one and made the other lighter.
I worked in graphite, using the broad stroke technique for the leaves. With this technique, the marks the pencil makes are very similar to those produced with strokes of a flat square brush. I make sure that the pencil is sharpened to a point where it can deliver a stroke parallel to the surface, so that when the mark is made, it sits smoothly on the surface of the paper, resembling a brushstroke.

Morning Light, Palm Trees
A scene from Paphos, Cyprus.

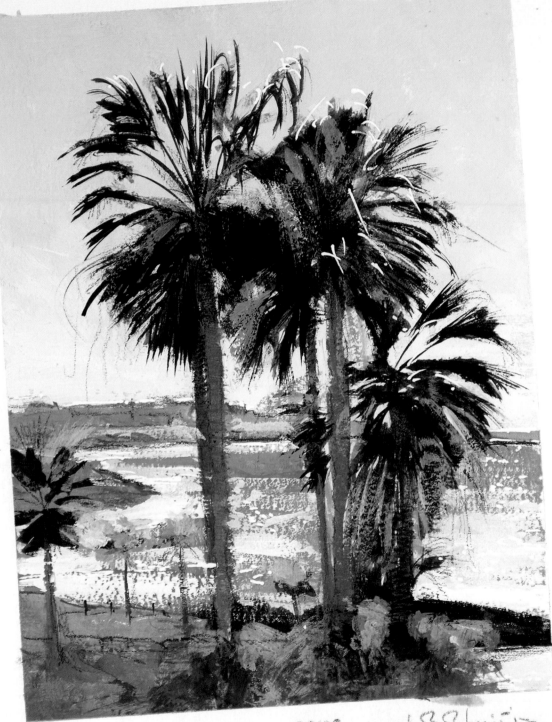

PAPHOS, CYPRUS.

Markets and meeting places

A fusion of colour, interesting shapes, and people, sketches and paintings of markets always end up vibrant. Because there are so many varied shapes to see, markets make great compositional frameworks.

When I go to the market I look out not only for things to buy but also for shapes that would make an interesting painting. I am constantly thinking, 'Oh, that shadow is connected to that seller's goods – and that's connected to that sudden blast of pumpkins.' Everything looks exciting, and so I often find a vantage point in the market area, sit down and sketch for hours to develop studies for different possibilities for paintings.

Because the light and the people move and change so quickly, it is a good idea to take a camera – that way you can record some very interesting scenes that are just too fleeting to sketch.

Each topic here just keeps getting more exciting. Markets! Oh, markets and colours!

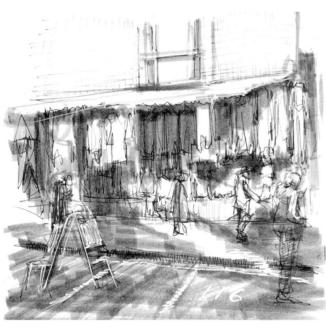

If I say every part of Portobello Road Market is interesting to sketch, that is definitely not an understatement. The market is colourful, busy, has a bit of retro feel to it and is a sketcher's dream. Here I have just captured one bit of stall 116 on the road using a fibre tip fineliner and a dual wash pen.

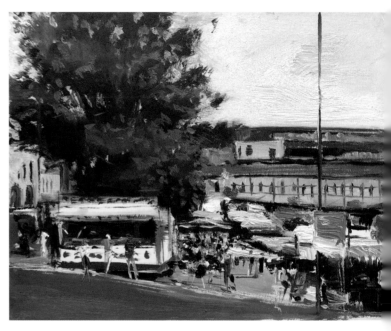

Bath Saturday Antique & Flea Market

In 2010 I set myself a challenge to paint over two hundred 15 x 20cm (6 x 8in) paintings of the city in four months; a challenge I called my 'Bath Marathon'. This is one of the *plein air* sketches I did. It is one of my favourites because I didn't need to overwork anything, capturing the market was so natural. The technique I used was to build up tones in the form of transparent washes – just like we do when working with watercolour – until the end when I introduced thicker colour. I did this in oil on a gesso-primed mountboard.

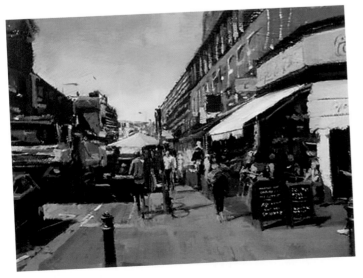

North End Road Market

I love North End Road Market in Fulham. It is always busy, but it is at its busiest during the weekends. My goal was to capture the colour and activities happening by using bold colours. This was painted in oil on board.

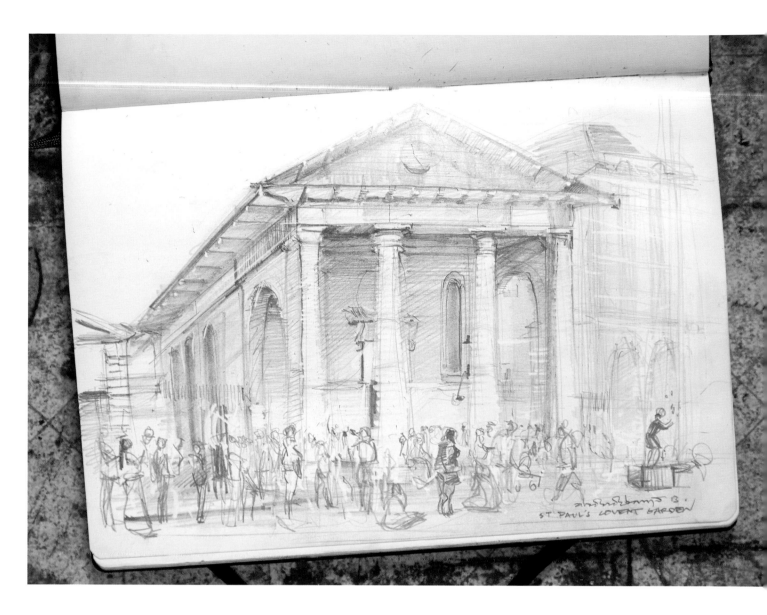

Covent Garden. I sketched here alongside Liz Steel, the prolific urban sketcher, when she visited London in 2013 (see right). We both sat down for some refreshments and drew at the same time. She drew in pen and ink if I remember correctly, but I went for my trusty first love: graphite.

Statue

I often go sketch hunting for statues as an opportunity to explore my love for drawing people, and because they give me a bit of information about the past – I always love a bit of history. As I mentioned earlier, the beautiful thing is that they don't move. Sketching them becomes a great exercise in learning proportions, depicting folds of clothing, and how to capture the features of the human figure.

This particular project is of a statue in my favourite place to sketch and paint in London, Sloane Square. We are using watercolour, which is the simplest of wet media, to capture the tones and solidity of the statue. I use watercolour in both an opaque and transparent way when making this sort of sketch. These colour studies can be done very quickly and work well for any sketcher who is travelling light, or who wants to keep moving around to explore the city they're in.

I painted this particular scene because I like the movement of the figure. There's an important point I would like to make here: even though I have said to make sure that you paint or sketch what you like, that doesn't mean you cannot give something you do not find interesting a go. The reality is that it is not always about what you paint, but about how you paint it. Putting your unique stamp on a sketch of something can make a big difference in your work. It's all about the interpretation you give it.

In this study, it's all about what I want you to see: the solidity, the tones and the movement. If you look at the way I have approached this and it inspires you to give a statue around where you live a trial, then I have achieved the purpose of this project.

1 Quickly measure to establish the proportions: here the figure is half the overall height of the fountain.

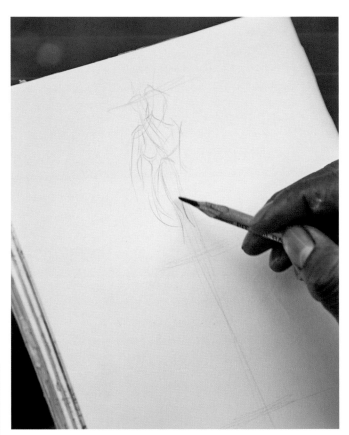

2 Using oil-based pencil, as it won't smudge or bleed when you work watercolour over the top, lightly draw a central line to place the fountain on the page. Use lines to sketch the limbs (try using the angles technique on page 22) and more organic, flowing marks for the curves.

You will need

Stillman & Birn premium soft cover
 sketchbook, 203 x 254mm (8 x 10in)
Brushes: sizes 12, 6, 2 and 00 round
Watercolour paints: French ultramarine,
 alizarin crimson, burnt sienna, cadmium
 orange, viridian, lemon green and
 yellow ochre
Gouache paint: Chinese white
Plastic spray bottle
Water pot
Tombow dual wash pens: sand (992), cool
 grey 1(N75) and warm grey 1 (N89)
Oil-based pencil

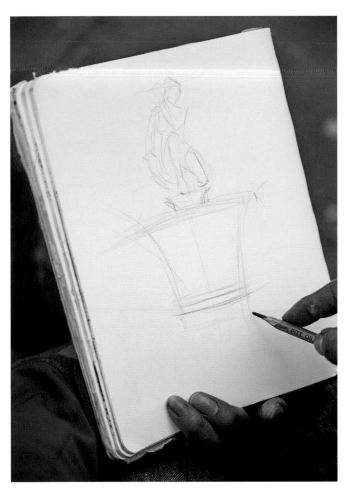

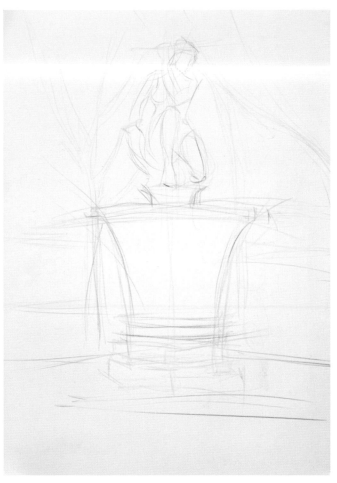

3 Establish the pedestal using light flowing marks – this is so that the lines don't dominate the later watercolour.

4 Suggest a faint background of trees and buildings to complete the initial sketch.

5 Set your watercolours down by your side and spray the colours lightly with water to soften them and get them ready for working.

6 Use a size 12 round brush to make a dark mix of French ultramarine, alizarin crimson and viridian.

Using a large brush forces you to work more freely and loosely.

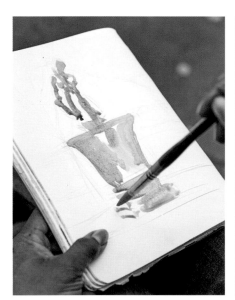

7 Begin to paint the statue, leaving gaps of white paper for highlights. Mix lemon green and yellow ochre for the pedestal.

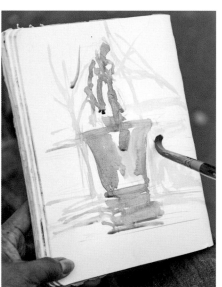

8 Make a grey mix of French ultramarine and viridian. Use this to hint at the background with loose, light marks. Draw with the tip of the brush to suggest traffic around the square.

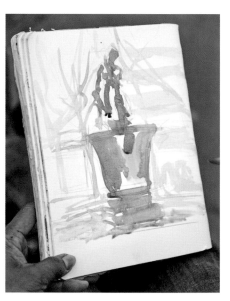

9 Use cerulean blue touches for the water around the fountain.

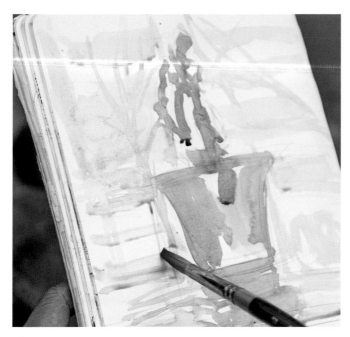

10 Use a mix of burnt sienna and cadmium orange for a light, brief suggestion of the building behind the fountain.

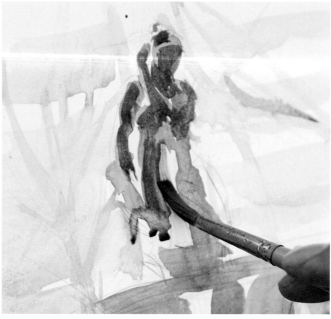

11 Change to the size 6 round brush and build up the figure with a more concentrated mix of the same colours: French ultramarine, alizarin crimson and viridian. Fill in some of the gaps and overlay previous layers in parts.

Don't overdo detail – remember that this is a sketch. Freshness and immediacy are vital.

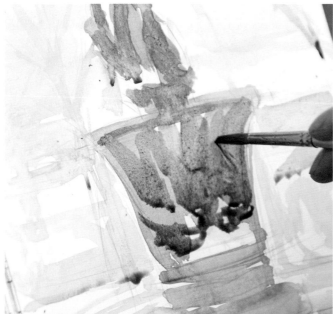

12 Add marks to suggest the design on the base. Don't be too concerned with accuracy: aim to suggest the shapes rather than reproduce them exactly.

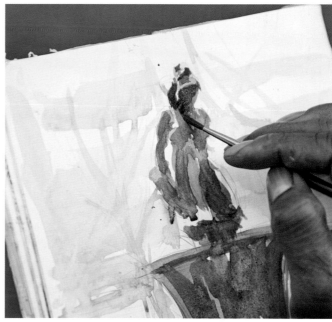

13 Change to the size 2 round brush. Use a very strong mix of French ultramarine, alizarin crimson and viridian to add rich darks with more controlled strokes.

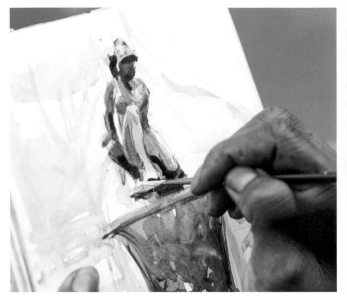

14 Add Chinese white gouache to the green mix (lemon green and yellow ochre) to add highlights to the pedestal.

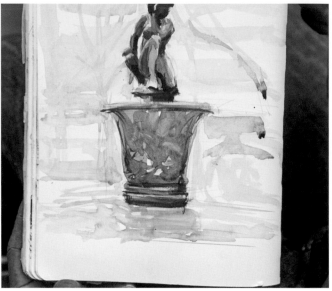

15 Add highlights to the base of the fountain with dilute Chinese white gouache.

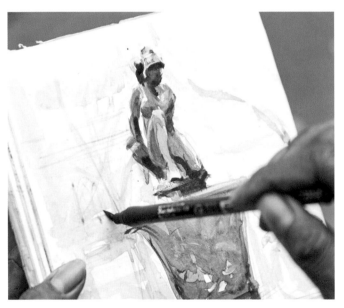

16 Add some fast exciting marks with the dual wash pens – but just a few. These subtle, energetic marks add movement and life without overpowering or overworking the sketch.

Everything should be fluid and flowing.

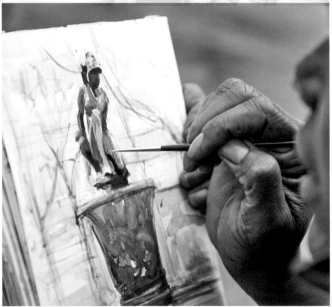

17 Add final highlights to the statue itself with white gouache and the size 00 brush.

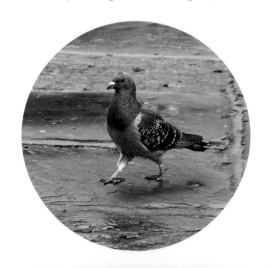

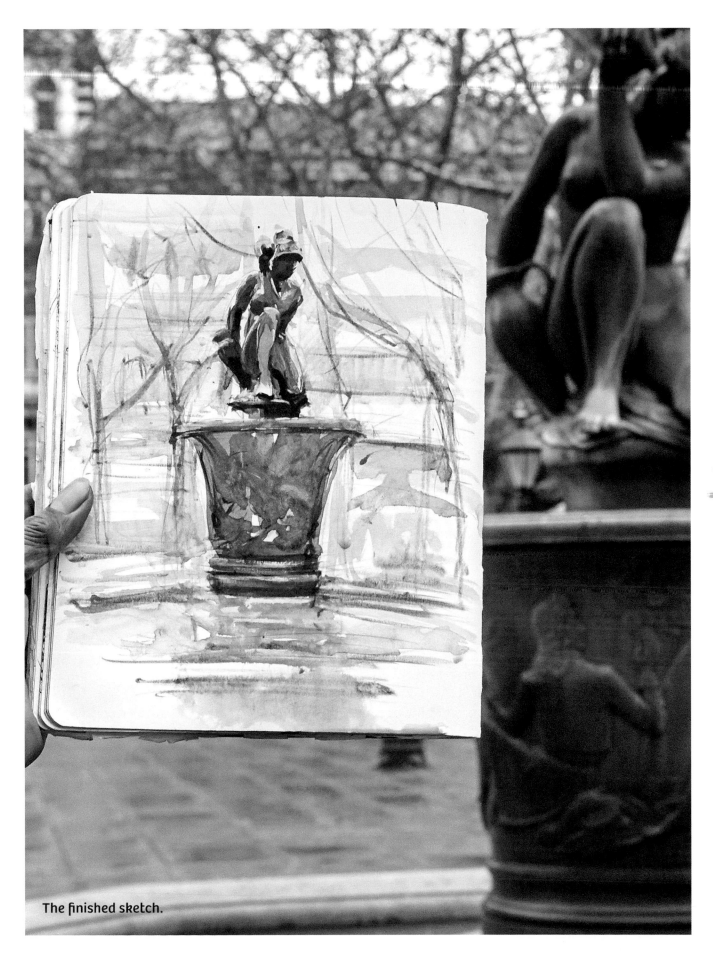

The finished sketch.

PLACES INDOORS

Your addiction to sketch must affect you everywhere you go, you must see opportunities everywhere. I have said this so many times in this book that you may be tired of hearing it, but because this book is meant to get you addicted to sketching, I'll never stop!

Indoor spaces offer endless opportunities. There are so many wonderful buildings that are simply inspiring, beautiful and have splendid interiors waiting for you to discover, explore and interpret in your own unique way. Most public places have people in them, which can add to the sketch, but sometimes even without the people they can still look great – some look best when the focus is on the space itself. You might decide to focus on a detail that catches your attention in the corner of a hall, an altar or a mantelpiece in a church or cathedral; or on the space as a whole.

There are some places where you would need to ask permission before you start sketching, but most public places welcome artists to work there, as they find it special that an artist has come in to their building to draw. Never assume a place will be out of bounds or a non-sketching place. If you are ever in doubt, just start sketching until someone says you shouldn't.

One more thing about sketching places indoors is that you must always remember to keep your perspective simple. Most indoors sketches work best with one-point perspective: it's straightforward and easy to understand. If it still gives you doubts, just use the simple method of lining up your pencil or pen to the angle you want to capture, then transferring that same angle on your paper. This was the easiest way for me to approach it.

Opposite:

The sketch was a lovely altar piece in a church at York. I was glad they allowed me in and the nuns were very helpful. No-one else came in and I had this place all to myself for two hours – I just sketched there the whole time!

Whenever you are allowed to, please go into any place of worship. Just choose a corner or a spot where light is coming in through the windows in early mornings or late afternoons and sketch – you won't be disappointed. There is such a sense of peace and serenity in those places that it does your creative instincts, and your soul, good to sketch there.

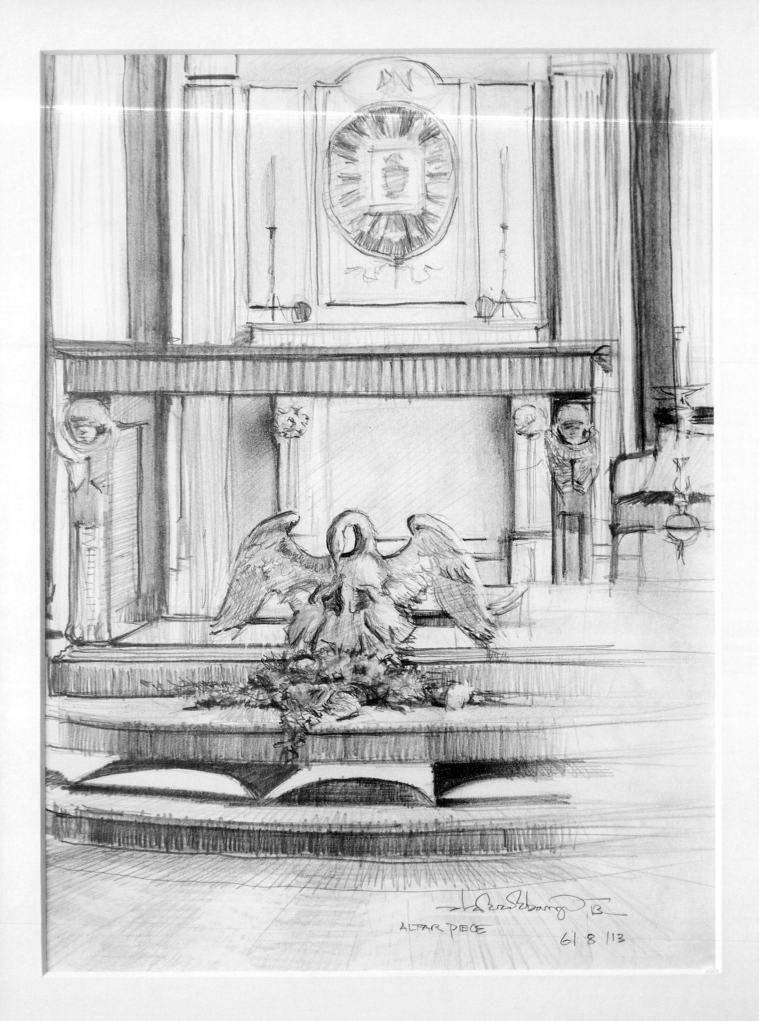

ALTAR PIECE

61.8.13

Museums and galleries

I think because we go to these places to view art, we can sometimes forget that they are good places to sketch too. Many people sketch the sculptural pieces and the paintings in a gallery – it's a great way to understand an artwork – but it's also worth capturing the surroundings along with the artwork. When next there's an exhibition on near you, go with your sketchbook and capture not only the paintings but the surrounding walls too. Add a few art-lovers keenly observing: they always help to make good pieces.

I used black and brown coloured pencils to capture these onlookers at the Van Gogh Exhibition in London in an Alpha series Stillman & Birn sketchbook.

I attended the wrap-up party evening of the Columbia Threadneedle Prize exhibition at The Mall Galleries. After spending a few moments meeting and greeting, I escaped to sketch this from the bookstore area, giving me a view of the gallery from a higher perspective. As an addictive sketcher, you must be ready to escape the crowds to sketch the crowds. I used Canson grey paper, sketching with a black ballpoint pen and a white coloured pencil for highlights.

Sketch of *Head of Isabel* by Alberto Giacometti (1901–1966) at the National Gallery in London. I really enjoyed this exhibition. This particular piece was mounted in a glass box. I just sat right in front of it and drew for almost an hour. There is nothing as satisfying as drawing in a gallery; you can also listen in on the comments of viewers; hearing what they think about various works while you sketch. I used a Papermate 100 brown ballpoint pen and light brown Tombow markers for this sketch

Offices and workshops

These are the places where you or other people work. The key thing here is making something special out of an ordinary space. There are many places to explore and sketch while you're waiting for an appointment at the doctor's, dentist's or barber's. Banks, office receptions and hospitals are other spaces to sketch – in fact, any place where you can watch people working can be a great place to get going with your sketchbook.

You can always go and explore new places too. The glassblower's sketch you see here was a space I had never been to. But I have always been fascinated about the whole process, so I decided to go into the workshop one day and ask whether I could come over to sketch – they were delighted, and this is the result.

Make every single place you visit an haven for your art. The world is your studio. Go into new places, and new workspaces; and have a think about what you could sketch when you are out and about. Kitchens are on my bucket list, for example – to just walk into a restaurant and ask if I can sketch the chefs cooking in the kitchen.

I want art to be part of life and to be part of people's lives – c'mon, let's do it! I'm sure you'll never lack a place or project to work on after reading this book!

I have always been fascinated about the process of glassblowing, so I summoned up my confidence, walked straight into this workshop, and told them I would love to sketch the workers while they were either glassblowing or putting the glass through intense heat. My request was granted and I sat down to sketch the piece below. You can see the picture of me sketching in the glassblowing workshop of Peter Layton at London Glassblowing to the right.

106

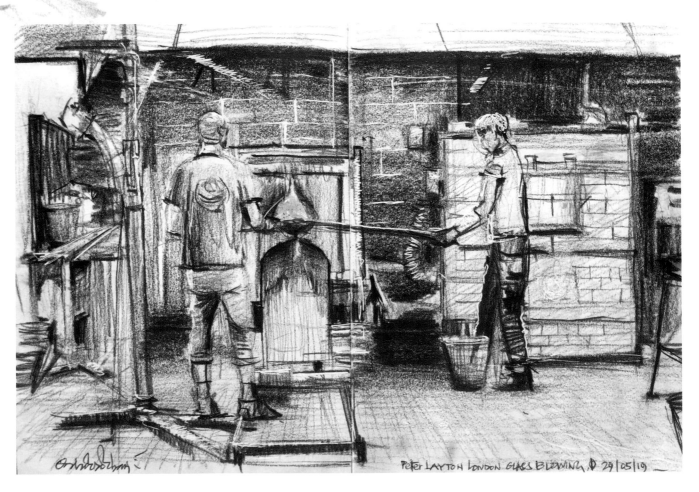

Peter Layton London Glass Blowing 29/05/19

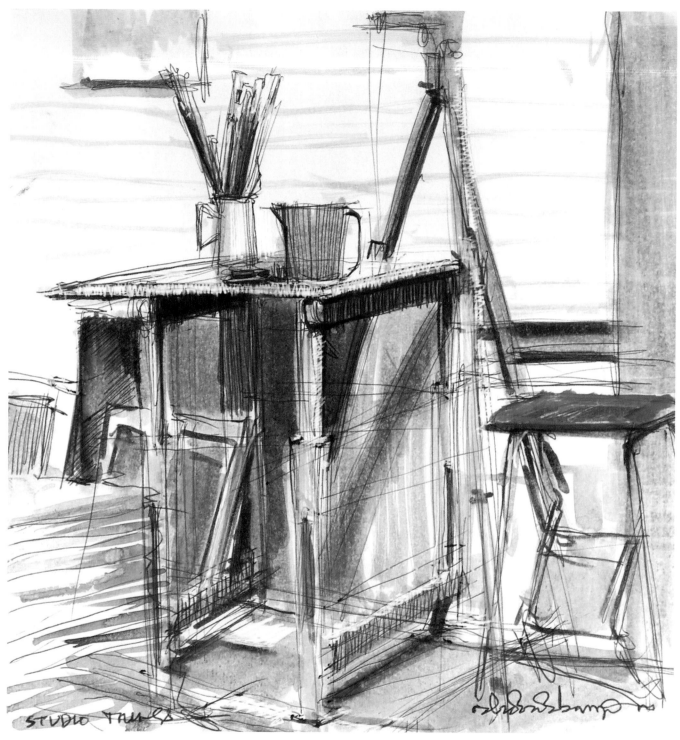

STUDIO THINGS

It's always good to explore what is right around you – this is
what is in one of the corners of my studio. I sketched this in a
small Moleskine paperback sketchbook with a brown ballpoint
pen, coloured pencils and dual wash markers.

Gallery

This project walks you through how to go into a gallery, position yourself and start sketching. This particular gallery is the Mall Galleries in London, and this sketch was done in January of 2018, when the Federation of British Artists' *FBA Futures* exhibition was going on. It had works of some of the finest art graduates from universities and art colleges around the country.

I normally pick a spot where I think I can see an interesting view that has a bit of depth to it: some pictures on the wall and room for people to be added in. I like an interaction between people and art, so being able to sketch this as it happens is really interesting. I make sure from the start that I mark where the heads of the average person will be when standing or walking, so that I can take this into account when sketching the walls and paintings.

You will need

Stillman & Birn premium soft cover sketchbook, 203 x 254mm (8 x 10in)

Derwent drawing pencils: Mars orange (0610), ink blue (3720), ivory black (8200), and brown ochre (3700)

Lyra Color Giants: brown

1 Use a midtone (Mars orange) to roughly sketch in the main shapes of the setting.

2 For indoor spaces, the perspective is particularly important, so add some lines to guide you.

3 Block in any artworks as simple shapes.

4 Loosely sketch in the shapes created by the arches, and use the side of the pencil to add an area of tonal shadow.

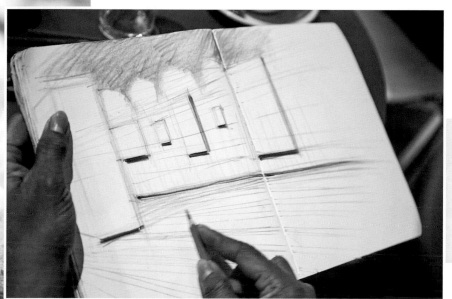

5 Use the large brown pencil to block in the heavy shadows beneath the artworks and across the sketch. Lyra's Color Giants range are big, chunky coloured pencils, with high-colour pigment for intensity; great for deep tones.

These shadows will show through figures later, but that's good – like a long-exposure photograph, it adds to the sense that the people are moving and temporary, in contrast to the walls and artworks.

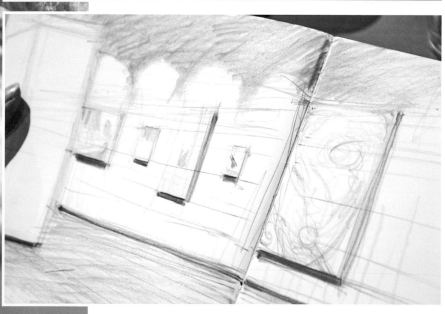

6 Use a cool colour to suggest the artworks themselves. I'm using ink blue. Don't try to reproduce them – just hint at the biggest shapes.

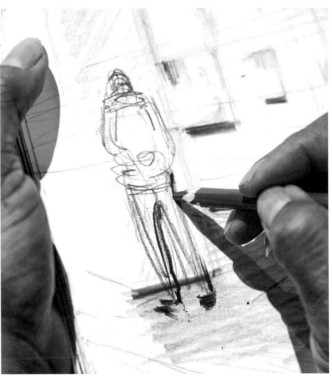

7 When someone stops to look at the artwork, immediately establish the position of the top of the head and the soles of the feet as quickly as you can, then sketch the rest of the figure using organic lines.

8 You can use a variety of approaches. This figure suits angular lines, so with the head and feet placed, fill in the figure with this technique.

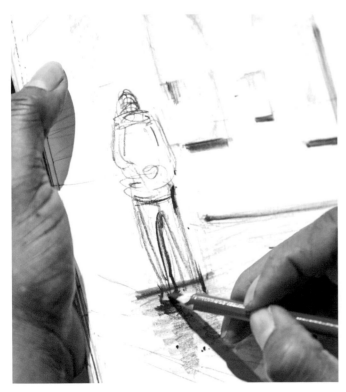

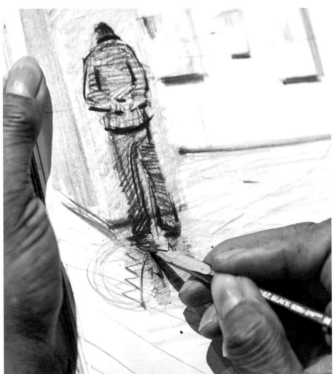

9 Use brown to reinforce the tone and create shadows. It is important to add shadows beneath the feet to give the figures weight and presence.

10 If the viewer stays in place, make the most of the time. Refine the unfinished figure; developing and building up the depth of tone. You can bring in other nearby details – here I'm adding part of a nearby artwork on the floor.

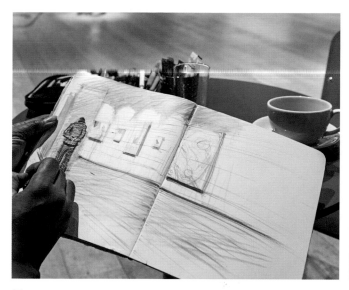

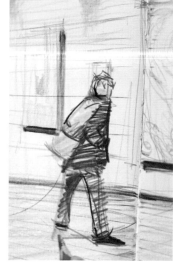

11 Keep an eye on the balance of the painting as a whole, too. Strengthen shadows and tone with overlaid marks.

12 Break off to add more figures as they appear. Use the lines established in the background to help you place them quickly.

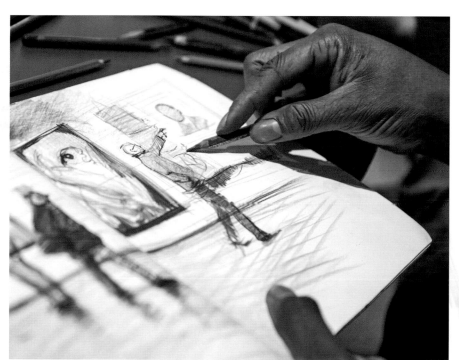

13 If you spot an eye-catching pose, feel free to extend the background – here the pointing figure was great, but too close to the existing viewer – so I moved him along, using the lines on the drawing to help place the head and feet correctly, then added another artwork.

14 When adding artworks, sketch enough detail for interest, but don't let them draw attention from the figures.

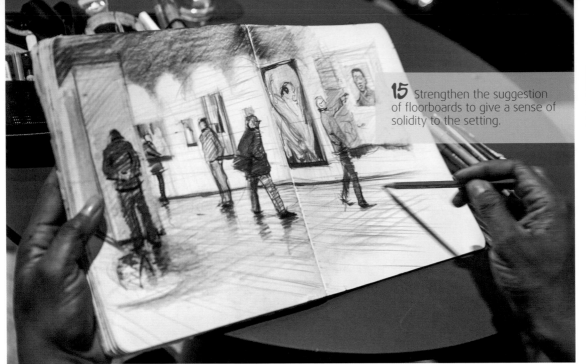

15 Strengthen the suggestion of floorboards to give a sense of solidity to the setting.

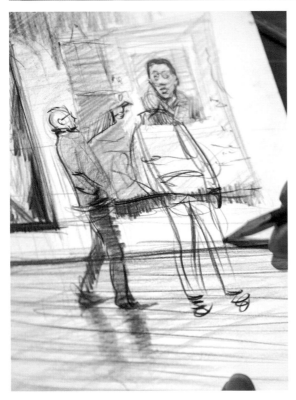

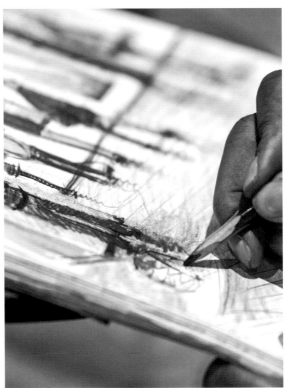

16 Some gestures can look isolated or odd on their own. Here I caught the pointing figure's fleeting movement, but missed his companion; so I waited for another person to stand in roughly the right area in order to make sense of the pose.

17 Don't over-crowd the sketch. When you have enough figures, tell yourself to stop, then refine and rebalance the picture to ensure that the viewers in the gallery don't distract from the space itself. Use other midtones – brown ochre here – to add some overlaying lines and to vary the tone.

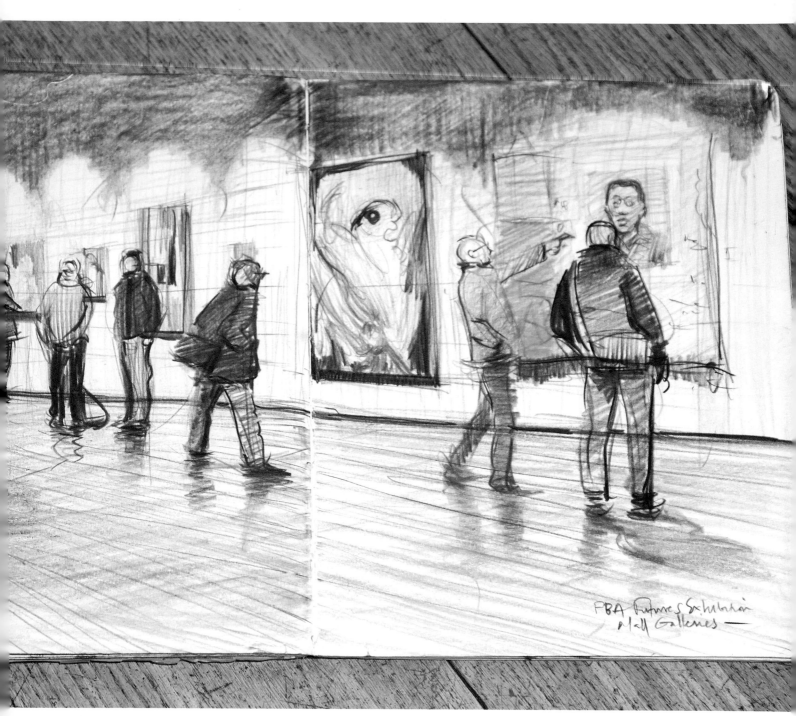

The finished sketch.

DISCOVER

This section is all about your travel to different places in the world; places to experience different weather and different climates. I would love you to discover the world. Wherever you go on the globe, you will find great inspiration for sketching, so it's important to sketch whenever you have the opportunity.

Whenever you travel to a new, unfamiliar place, please go with your sketchbook and sketching tools. Make sure that you steal some time or schedule a sketching routine into your time there. If you do not plan it, it won't happen. Try sketching early in the morning, or some time when you know there isn't going to be much disturbance.

If you are looking to get some variety in your work, but can't travel, you can discover how your local area looks at different times in the year. Sketching the same place in different seasons will reveal new, surprising aspects about the familiar landscape. You can also decide to sketch the same place under different weather conditions or lighting – a place can look very different in the morning from the same scene in the dusk.

Your role is to put on your discovery brain, act like scientist or explorer and always see if there's something new or a clue to something new! I have always noticed that when artists from other countries come to London, where I am based, they find everything interesting to sketch – the buildings, the buses, the landmarks – everything just seems worth recording. If they lived here, I doubt they would feel the same way. It is easy to develop the feeling that you have seen it all before – but that is never true. To avoid that mindset, I make it a deliberate practice to sketch in my city. Every month I sketch a new place or I sketch somewhere I have sketched before in a new light.

I aim to re-discover or re-interpret familiar scenes in a different way, or at a different time of the day, or at a different time of the year. Let's take off and let's discover the world in a new way!

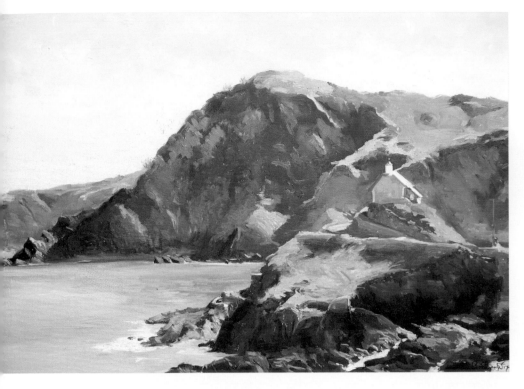

Seasons

Every season has its own appeal and set of challenges for sketching.

SPRING

This is the birth of beauty. It is as if everything comes to life in spring, and it is almost as if there is something to sketch everywhere. Part of this impression likely comes from the fact that one has been indoors for most of the preceding season, avoiding the cold weather. When spring arrives, I am able to venture on my first *plein air* painting trips for a while.

Morning Light, Ilfracombe
On this striking spring day, the mountains at Ilfracombe had a special strong light and feeling that I wanted to capture.

116

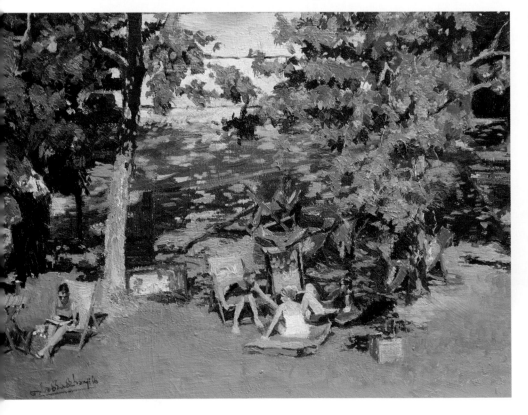

SUMMER

This is the season where everything is high, full and green; and when the sketching and painting season comes to full blast – the light is perfect! Even in the summer it is still beneficial to work in the mornings and the late afternoon or evenings because there are dramatic shadows that really help the composition at this time. Moreover the summer sun can be too harsh to sketch in when it is directly overhead.

Summer Shadows, South Bank
Painted during the full blast of summer heat. You can see that the ladies under the trees are almost all in the shade to protect themselves from the heat.

AUTUMN

When the leaves turn golden and brown, autumn is the most exciting season for sketching. Don't neglect yourself when sketching outdoors: this is also a time when the weather worsens and the temperature begins to drop. Working outdoors in the autumn demands we wear clothing that will keep us warm and protected.

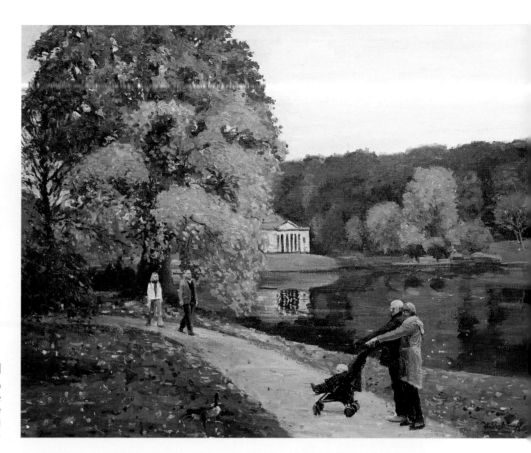

Autumn, Stourhead
Autumn can end up looking almost too picture-perfect, so while painting the autumn leaves here, I played down some of the colours so it didn't end up looking too good to be true.

WINTER

As much as I dislike cold weather, it never stops me from longing to paint or sketch in the snow. The snow is the only thing I like about winter and in recent years in London, we have had very little snow. This means when there is a forecast of snow, I get excited and just can't wait to get out with my painting gear. It comes back to what I said earlier in this chapter – we tend to be most appreciative of what we don't always have.

Snow, Sunshine & Shadows
The painting here was the only snow I saw this year. Once I realized there was snow, I rushed outside and did the painting with so much joy, I hardly felt the cold.

Time of day

You don't have to wait for the seasons to change for a new challenge. Try visiting and sketching the same places at different times of day – or night.

From Whistler to Van Gogh to John Grimshaw, many past masters loved night scenes, or nocturnes. Their work has been a great inspiration for me. In Nigeria, my teacher, mentor and friend Abiodun Olaku really made me love night scenes even more.

The reason I love working at night is because there are not many people around. It is also easier, because one needs to focus only on tones and not much on temperature when mixing colours.

When going to sketch at night, make sure you go with someone if you are not comfortable going alone. However confident you are, make sure your phone is charged, just in case you need to make a call to let people know of your whereabouts. I usually take a head torch for sketching at night, and a nice foldable stool to sit on, too. Oh yes, I'm a bit of a lazy one: when it comes to painting or sketching outdoors, I prefer to sit. Find what works best for you!

A night scene of Pulteney Bridge in the city of Bath. This sketch brings back so many good memories: in particularly of a four-month period in which I completed two hundred paintings of the city. It also evokes less pleasant memories: I was approached by the police around 2am while making this sketch. They were very suspicious, and just could not understand why I decided to do it at night. I told them that it was simply because I wanted to paint the way the bridge looks at night. I think I got away with it!

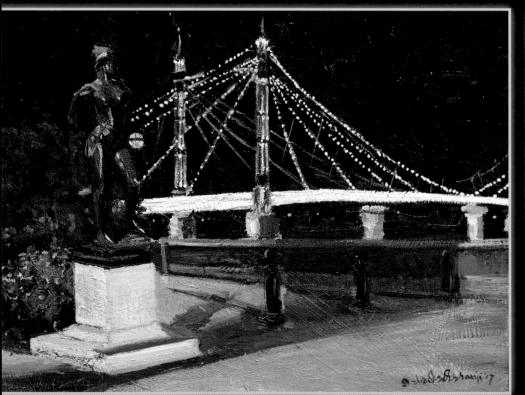

Derwent Wood Figure and Albert Bridge Nocturne

This was painted very late at night from 11pm to 1am. There were not many people around when I did this one but I enjoyed it. As you can see from the photograph above, I had my head torch on, ready for my night adventures.

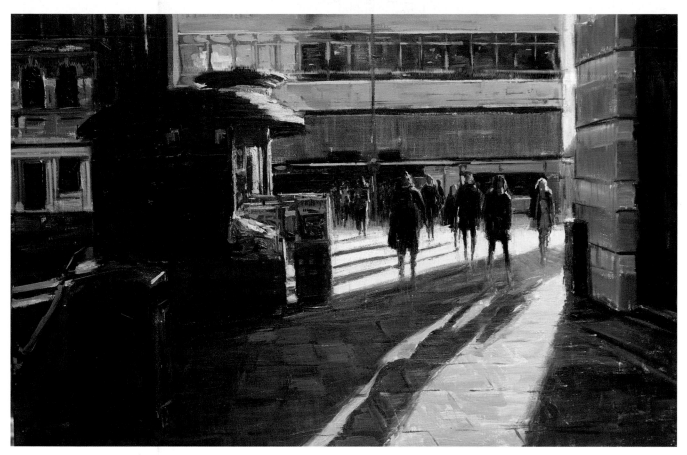

Mornings and evenings are the best times to sketch and paint because the light is always dramatic. Coupled with the long shadows the low sun produces at these times, these times of day can really help in making great compositions that look dynamic and full of abstract quality.

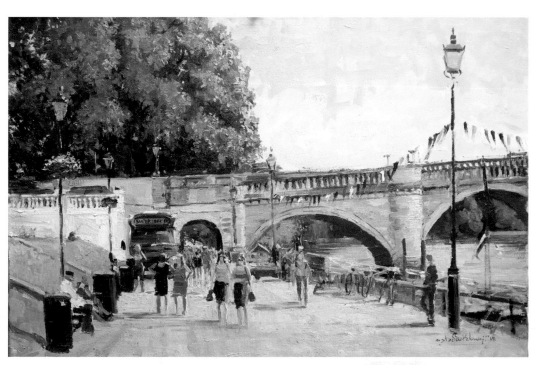

Afternoons can be tricky because most of the light is directly above, which makes the scenes a bit flat and highly contrasted. They are worth experimenting with, however, because the results can be very pleasing. My final words of advice here are simple: discover what time of the day works best for you – and go for it!

Travel

Travel opens new doors to sketching. In fact, this is the most inspirational, exhilarating and uplifting of all the ways to take your sketching and painting to the next level. Experiencing new places is like immersing yourself into a whole new world. Over the past few years I have been to Japan, Cyprus, Portugal, Spain and Nigeria and you can see here sketches I did on my travels to these places. Going to a new place to experience it firsthand is totally different from just reading about it; this will show in your art.

When you travel, don't visit only the tourist areas or iconic attractions. Instead, take a walk through the sidestreets and alleyways: the places that are less refined are the places that will spark your imagination with their simplicity – if you were indifferent about a place before visiting, these areas are the ones that will surprise you. Go on walks, not knowing exactly where you are headed, but always looking to discover something new by chance. Trust in serendipity!

Before travelling make sure you do your research and find out about the people, their habits, the dos and don'ts – and a little bit of the language. This will always help your trip turn out to be a more pleasant and rewarding one.

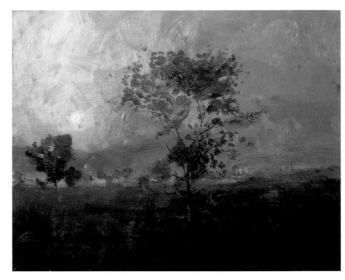

Dawn in Abuja, Nigeria

The light in Nigeria is totally different from the London light, but it is beautiful all the same. Here, the light was flat, with no clouds in the sky – but there was an early morning moon about to disappear. I exaggerated the colours a little by making them a bit more saturated than normal. The wide-open lands in this part of Nigeria seem to go on forever. It is like a mini paradise.

The Opera House, Vienna, Austria

I sat down at an Italian restaurant opposite this magnificient building to have spaghetti bolognese, and just before I started eating, I sketched this amazing place with a ballpoint pen, dual wash markers, gouache and white pens for highlights. The painting I made after the study is shown below.

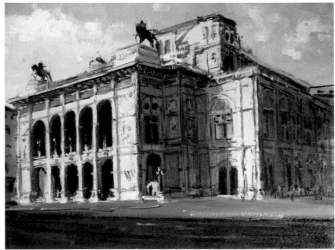

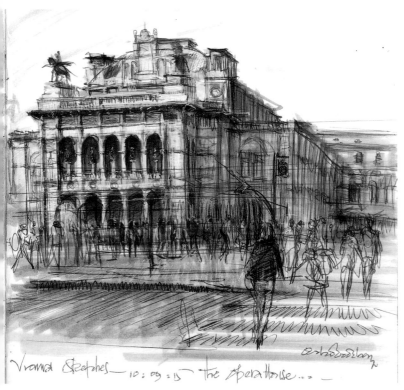

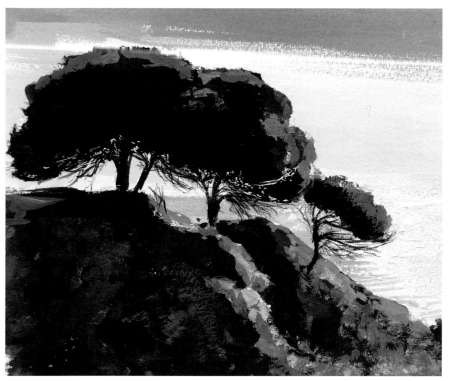

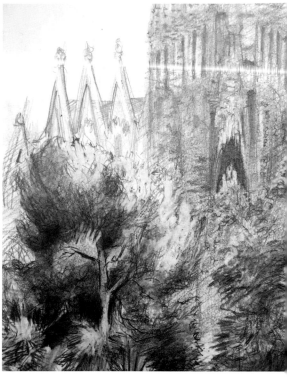

Albufeira, Portugal

I love the coastline at Albufeira, it sparkles during the day with the sunlight dazzling right from the horizon to the foreground. I completed this sketch with gouache and a white ink pen for extra highlights on a heavy watercolour paper.

Sagrada Familia, Barcelona

I have only caught one side of this magnificent structure in Barcelona. For once, I didn't know where to start sketching! I had to go to the easiest part of the building to find a way of capturing at least a bit of it. I worked with graphite in my sketchbook.

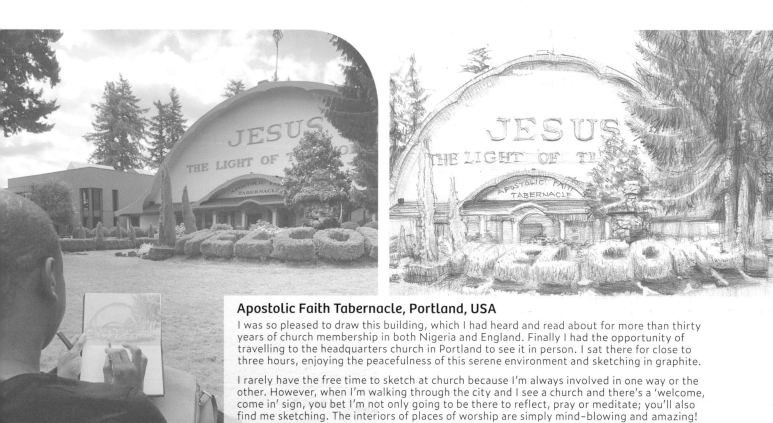

Apostolic Faith Tabernacle, Portland, USA

I was so pleased to draw this building, which I had heard and read about for more than thirty years of church membership in both Nigeria and England. Finally I had the opportunity of travelling to the headquarters church in Portland to see it in person. I sat there for close to three hours, enjoying the peacefulness of this serene environment and sketching in graphite.

I rarely have the free time to sketch at church because I'm always involved in one way or the other. However, when I'm walking through the city and I see a church and there's a 'welcome, come in' sign, you bet I'm not only going to be there to reflect, pray or meditate; you'll also find me sketching. The interiors of places of worship are simply mind-blowing and amazing!

PAINTING

I see painting simply as sketching and drawing with colour. I never separate the painting process from the drawing process in my head. Every painting stroke is a drawing stroke: each time you put a brushstroke with paint on the canvas or board, you are trying to make sure that stroke is positioned correctly, proportional to whatever you are about to paint. It must also be the right shape, following the form of what you are painting. Finally, these marks must come from correct judgements made from keenly observing what you are painting. All this is purely the drawing process. All those measurements, estimations and proportional planning are part of a full-blooded drawing process. The only difference is the mixing of the colours that also takes place alongside all of that.

If one ignores all the drawing skills built up through sketching, focussing only on the mixing of colour, and is sloppy in making assessments of where the stroke will land on the surface, then I believe that has trespassed the boundaries of representational painting. But even the abstract painter makes these judgements – if not, the painting produced will be utter chaos.

My philosophy is hard-core drawing all the way through. It is the way I think, and the way I paint. There is always a little voice in my head while painting that keeps insisting, 'draw… draw… draw.' This is what I would love you to embrace while we delve into the world of painting. It is always safer to have a painting that is founded on solid drawing, than to have all the beauty of colour, texture and temperature without the sound foundation of an accurate drawing.

The other thing that must be included in any sort of painting is a strong value pattern. This is mentioned in the section on value and colour (see pages 42–45). The value pattern must look interesting and must work in an abstract sense. If it doesn't, the work will lack the punch that will make it stand the test of time, no matter how skilfully it is painted. Painting demands planning and part of that planning means making a series of sketches and studies before fully embarking on the final painting.

THE COLOURS I USE

- Titanium white
- Cadmium lemon or lemon yellow
- Cadmium yellow pale or light
- Cadmium yellow deep
- Yellow ochre
- Terra rosa

- Cadmium red
- Alizarin crimson
- Transparent oxide brown
- Ultramarine blue
- Cobalt blue
- Viridian green

MIXING COLOURS

My process of mixing colours is quite simple. First I look keenly to find out the natural colour (hue) of what I'm painting. I look at my palette for the closest colours to that natural colour, then mix on my palette to further improve the match. The final question I ask myself is: 'Does it need to be lighter or darker, or does it need to be cooler or warmer?' Once I determine these facts, I refine the mix accordingly.

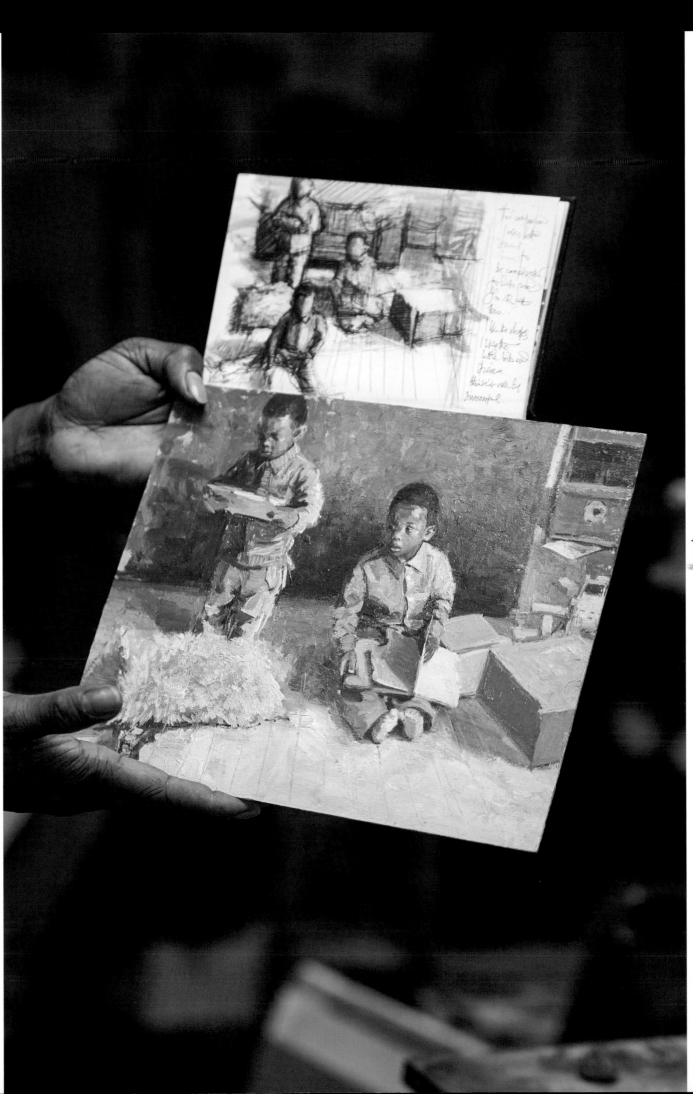

Sketching for painting

Sketching is the lifeblood of any successful painting. What happens in the sketching stage is crucial to the successful outcome of the painting. Many great artists of the past produced dozens and dozens of studies and sketches for their work so that by the time they came to execute a painting, it was destined to become a magical masterpiece; a fitting result for all their preparation and hard work.

Joaquín Sorolla (1863–1923), for example, did a huge number of studies for his masterpiece painting entitled *Sad Inheritance*. This particular painting depicts many disabled boys in or near the sea, with a priest in black lending support to one of the children. There are close to twenty-five figures in the painting, and even a master like Sorolla had to rely on the power of sketching. Studying the anatomy and practising on smaller surfaces allowed him to produce an immensely powerful finished piece. This is a great lesson for us in this age of quick deliveries and microwave delicacies. We must get back to refining our 'sketch-ability' to bring our painting to a reputable standard.

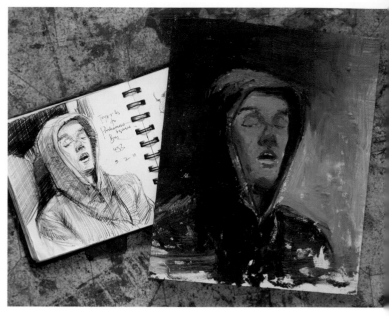

The Snorer #I

A sketch of a commuter I encountered on the train. I developed a habit of sketching and then returning to the studio and painting from just the sketch with no other reference. The experience is great as a good opportunity to master painting from memory.

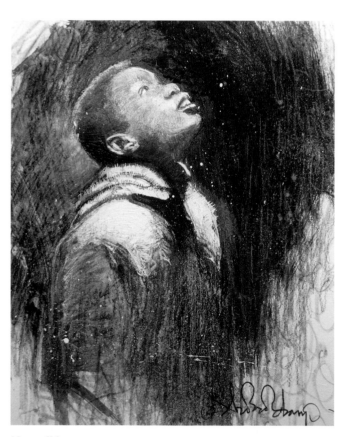

Hope IV

I was very fortunate to capture my son at this particular moment. We had just finished Bible study on a Wednesday at church and were walking to the car park when he looked up at the lights at the back wall in the parking space. At that moment,

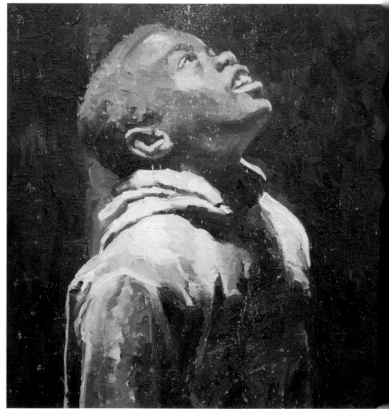

I just said, 'freeze'. I didn't have my sketching equipment, but I snapped the moment on my phone, and used the picture as a reference for both the sketch and painting shown here. I titled it 'Hope' because I think we all need hope to survive in this world!

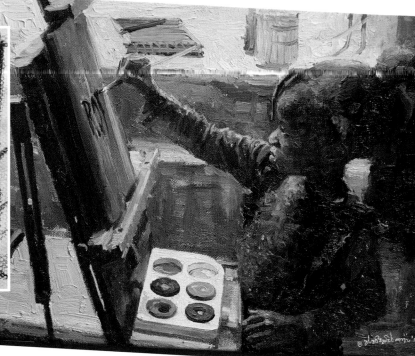

Kezia painting
Another example of sketch and finished painting together.

HOW SKETCHES HELP TO IMPROVE AND INFORM PAINTINGS

- Your ability to sketch will help you get a sound and solid drawing for your painting. This is the foundation of good painting.

- Your ability to sketch comes in handy to keep your work alive and full of energy. You know what to emphasize and what to leave out. You pick up this habit while sketching under pressure and it becomes invaluable while painting; because you still want your finished paintings to come across with an element of life and full of spontaneity.

- Sketching also helps you to be able to take on subjects that you might otherwise find daunting. For instance, in portraiture, a lot of people avoid the hands because they are a bit tricky. Imagine if you had sketched over fifty hands in the last few weeks: you would be able to take on that portrait commission with ease and confidence.

- Your accuracy with proportions will improve along with your skills in sketching, because you will be used to getting your estimates right through the practice of addictive sketching.

- If you are a painter who loves to work alla prima – that is, in one sitting – your work will improve because sketching will equip you to take greater risks with your work. Confidence comes naturally to the addictive sketcher.

- Being able to sketch fluently means you will be able to take on any subject with a level of fearlessness. For instance a lot of people avoid urban landscapes because they are not comfortable with straight lines, but by constant sketching you will be able to pull off those lines with ease. In fact, they really do not need to be straight lines: I love a sketchy inspired line as much as, if not more than, a mechanical straight one.

- When you are at the planning stage, still roughing out an idea for a painting and working on the composition and design, your ability to sketch will help you to explore many more possibilities: nothing will hold you back.

How I develop my ideas

Ideas for painting arise from everywhere. Nature, our environment, the surroundings, the world at large – all are beaming with ideas ready to be depicted on canvas. Ideas of what to paint come to us all. If you are anything like me, they torment me until I have the courage to bring them to life.

Each of us sees the world through a certain paradigm and our interests and tastes are as varied as our faces. To execute a painting, we must first trust ourselves and be true to who we are. Never allow what others think to affect your own personal vision. See it and say it in your own language. With that said, I believe allowing the idea to pass through the stages below will help it to come into being strong, refined and fully-developed, ready to stand the test of time.

What are the stages? In art school in Nigeria at Yaba College of Technology it was almost forbidden not to follow this sequence but I always longed for a shorter process and couldn't wait to just jump into the painting itself. What I didn't know at the time was that this training was the perfect bedrock to all successful work!

1 – ROUGHING OUT THE IDEA The first thing is to sketch out little thumbnails of your idea in various formats, to explore what the finished painting might look like. I'll make three or four such rough sketches, then choose the one that communicates the theme most strongly.

2 – TONAL DRAWING From the chosen rough I will then pose the sitter in that format and do a solid pencil drawing from it. This pencil drawing will be fairly accurate with the right tonal distribution. I normally do this in pencil or another dry drawing medium, such as charcoal.

3 – COLOUR ROUGH This stage is where I work on the colours as I want them to appear in the final painting. The only difference is that it won't be as detailed and refined. I usually work colour roughs at a relatively small size; perhaps an A4 sheet – 210 × 297mm (8¼ × 11¾in) – or smaller. The smaller the better, in fact. I normally do colour roughs in gouache, coloured pencils and Tombow dual wash pens, and I love to combine mixed media for this stage. The goal is to have a coloured representation of what the final painting will look like, creating accurate notes for yourself of the dominant colour, the value pattern, the colour harmony and the overall composition.

4 – THE FINAL PAINTING Once I'm satisfied with the colour rough, it is time to execute the main piece. The learning experience I gain from these stages is so immense that by the time I get to the main painting, it is straightforward and easy. Followed closely, these stages use your sketching skills to foresee and resolve any possible problems that may arise in moving from idea to finished painting.

REALITY

Today, I tend to supplement this approach with the use of my camera, but some twenty years after leaving college, the practice above still forms the bedrock of my thinking and planning process. In truth, I seldom go through all the steps as thoroughly as they are explained above, but when I do, it always results in a great painting.

126

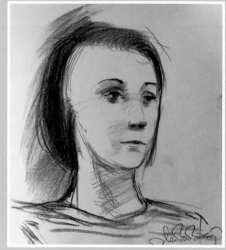

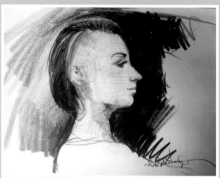

Roughing out the idea

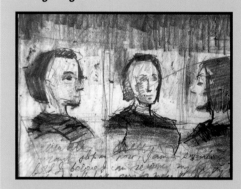

Tonal drawing

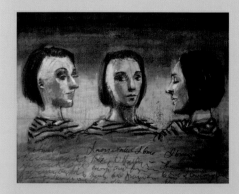

Colour rough

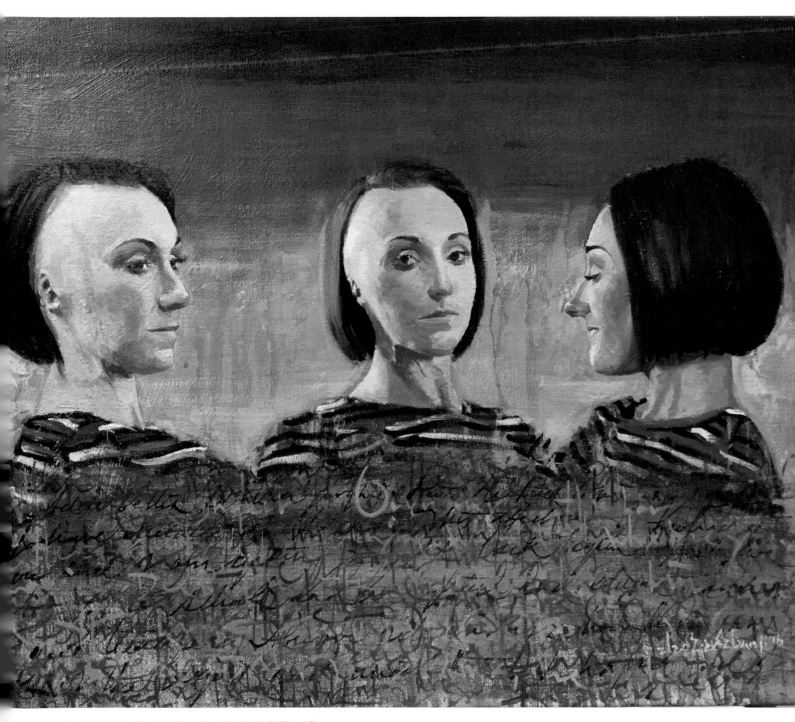

THE FINAL PAINTING: ADELE BELLIS

I was commissioned to do this portrait of Adele Bellis by *The One Show* on BBC One. Adele is an acid attack survivor. I planned to produce three sides to her face as I thought just one would not do her justice. I also wanted to make sure that one of the poses showed no trace of the acid attack, so the last image on the right shows a part of her that doesn't reveal any scars. I made several rough thumbnail studies of Adele's face, two of which can be seen on the opposite page. I followed this up by doing a pencil study (tonal drawing) in graphite and colour rough in gouache, pen and coloured pencils on a buff-coloured paper, before committing to the portrait itself.

INDEX

abstract 37, 119, 122
accuracy 12, 24, 33, 72, 84, 99, 125
animals 6, 8, 11
attitude in public 13

background 28, 35, 36, 61, 73, 77, 79, 97, 98, 111
balance 34, 37, 39, 78, 92, 111
ballpoint pen(s) 16, 18, 19, 32, 49, 50, 52, 58, 62, 90, 104, 105, 107, 120
bar 50, 56, 57, 58, 59, 60, 61
boats 82
body language 66, 74
bridge 86, 89, 118
broad strokes 16, 18, 19, 85
brushes (paint) 16, 19
brush pen(s) see also dual wash markers 19, 24, 89
building(s) 6, 20, 27, 57, 61, 77, 79, 82, 87, 88, 89, 92, 97, 99, 102, 110, 114, 120, 121

café(s) 50, 51
challenges 15, 116
charcoal 19, 30, 31, 84, 126
colour 19, 28, 34, 35, 36, 42, 45, 51, 65, 94, 96, 109, 122, 126, 127
coloured pencil(s) 19, 21, 45, 51, 55, 88, 90, 104, 107, 109, 126, 127
colour rough 126
composition 34, 35, 36, 37, 38, 39, 50, 66, 116, 119, 125, 126
confidence 10, 11, 13, 59, 106, 125
contrast 34, 35, 42, 57, 61, 78, 79, 82, 87, 109
crowds 28, 32, 64, 65, 68, 73, 74, 104, 112

darks 19, 30, 36, 44, 59, 60, 99
depth 40, 56, 61, 78, 108, 110
detail(s) 10, 18, 19, 26, 30, 42, 50, 61, 65, 74, 85, 91, 92, 99, 102, 110, 111
direction 13, 21, 23, 30, 35
dominance 34, 36, 38, 42, 45, 74, 126
drama 84, 116, 119
dual wash marker(s) 16, 19, 28, 48, 50, 51, 52, 56, 59, 74, 94, 96, 100, 107, 120, 126
dynamism 33, 39, 77, 86, 91, 119

energy 40, 55, 125
eye level 39, 41

faces 8, 13, 54, 70, 74, 126
figures 28, 29, 32, 33, 59, 60, 66, 72, 74, 90, 109, 110, 111, 112, 124
fineliner pens 16, 18, 94
flow 18, 28, 32, 35, 56, 59, 89, 96, 97, 100
focal point 38, 39, 86, 92
foreground 40, 61, 79, 121
fountain 96, 98, 99, 100

gallery(-ies) 13, 104, 105, 108, 112
gestures 74, 112
gouache 16, 19, 51, 96, 100, 120, 121, 126, 127
gradation 34
graphite sticks 18, 23, 76

habit 8, 15, 46, 50, 54, 72, 124, 125
harmony 34, 45, 86, 126
highlights 16, 18, 30, 31, 33, 42, 44, 59, 62, 81, 84, 85, 98, 100, 104, 120, 121
home 6, 15, 21, 46, 52
homeless people 13, 70, 71
horizon 39, 40, 41, 121

inspiration 5, 12, 14, 114, 118
 developing ideas 126

landscape(s) 12, 64, 82, 84, 86, 92, 114, 125
light(-ing) 8, 24, 34, 35, 36, 37, 42, 43, 44, 45, 56, 60, 68, 72, 79, 82, 85, 86, 89, 92, 93, 94, 96, 97, 98, 99, 102, 105, 114, 116, 119, 120, 122
lines 16, 18, 20, 22, 23, 24, 28, 29, 31, 32, 33, 35, 40, 41, 48, 49, 50, 54, 57, 58, 59, 65, 68, 72, 74, 77, 78, 79, 85, 88, 92, 96, 97, 108, 110, 111, 112, 125

Mall Galleries 104, 108
market(s) 6, 85, 94
marks 6, 16, 18, 19, 22, 30, 34, 35, 55, 76, 77, 84, 87, 92, 96, 97, 98, 99, 100, 111, 122
matching subject to technique 32
measuring/measurements 20, 89, 122
motion 21, 29, 39, 81
motivation 8, 12, 14, 15
mountains 82, 84, 116
movement 6, 24, 25, 28, 29, 32, 33, 55, 66, 72, 74, 79, 81, 91, 96, 100, 112
museum(s) 13, 104
musicians 13, 73, 76, 78

Nigeria 6, 11, 118, 120, 121, 126
night 13, 118
notan 37

observation see seeing
office(s) 106
oil-based pencils 16, 19, 30, 84
outline 22, 24, 58

painting 19, 31, 34, 35, 36, 37, 38, 39, 41, 42, 43, 45, 46, 65, 72, 73, 74, 76, 84, 86, 91, 92, 94, 111, 116, 117, 118, 120, 122, 124, 125, 126
 from memory 124
 mixing colours 118, 122
 sketching for 124
passion see also motivation 6, 7, 14, 15, 54, 64, 74
pencils 16, 18, 19, 21, 26, 30, 51, 76, 84, 90, 104, 107, 108, 109, 126, 127
 sharpening 16, 21
perspective 34, 40, 41, 90, 92, 102, 104, 108
photograph 55, 61, 65, 74, 109, 118
plan(-ning) 15, 42, 43, 45, 56, 74, 114, 122, 125, 126
portraits 12, 90
progress 8, 12, 15
proportions 20, 22, 27, 89, 96, 125
pub(s) 50, 51, 56, 59
public transport 13, 46, 52, 54, 114
 tips for sketching in/on 54

reference material 50, 66, 73, 74
reflected light 44
repetition 34
rhythm 34
risks 7, 20, 125
routine 15, 114

scale 92
seasons 114, 116, 117, 118
seeing 8, 12, 14, 20, 26, 45, 54
shadow(s) 8, 24, 26, 36, 37, 42, 44, 45, 59, 60, 78, 79, 80, 92, 94, 109, 110, 111, 116, 119
shape(s) 22, 24, 26, 34, 35, 36, 41, 49, 50, 56, 57, 76, 77, 79, 85, 86, 87, 89, 90, 94, 99, 108, 109, 122
simplicity 40, 42, 45, 90, 120
sky 39, 89, 92, 120
sleeping 13, 46, 52, 54
smartphone(s) 13, 26, 46, 68
social media 15
statue(s) 41, 90, 91, 96, 98, 100
story 37, 70
street(s) 40, 50, 64, 66, 68, 86, 87
sun/sunlight 79, 86, 116, 119, 121

techniques
 angle(s) 7, 13, 22, 23, 32, 35, 40, 41, 44, 102
 contour(s) 7, 22, 24, 25, 28, 32, 33, 46, 56, 58, 59, 74
 ghosting 30, 31, 33, 84
 structure 26, 27, 32, 78, 121
 organic lines 28, 29, 32, 33, 57, 65, 68, 72, 74, 77, 88, 110
temperature (colour) 35, 45, 118, 122
texture(s) 8, 35, 78, 92, 122
thumbnail (sketch) 42, 50, 127
time of day 15, 37, 45, 56, 82, 85, 92, 102, 104, 114, 116, 118, 119, 120
tonal drawing 126, 127
tone(s) see also value 19, 23, 24, 28, 30, 32, 34, 35, 36, 37, 42, 43, 44, 54, 56, 62, 74, 77, 78, 79, 80, 84, 86, 94, 96, 109, 110, 111, 112, 118
trains see also public transport 13, 20, 52, 54
travel 24, 82, 88, 114, 120
tree(s) 6, 8, 82, 84, 85, 90, 92, 93, 97, 116

unity 34
urban landscape(s) 12, 86, 92, 125

value 19, 37, 42, 43, 44, 45, 51, 122, 126
value pattern 37, 42, 122, 126
vanishing point 41

watercolour 16, 19, 55, 74, 86, 94, 96, 97, 121
weather 70, 114, 116, 117